LIFE SCIENCES BUILDINGS, BEN-GURION UNIVERSITY OF THE NEGEV

ADA KARMI-MELAMEDE, ARCHITECT : **LIFE SCIENCES BUILDINGS, BEN-GURION UNIVERSITY OF THE NEGEV**

Ada Karmi-Melamede
David S Robins

Principal Photography: Hélène Binet

BIRKHÄUSER PUBLISHERS FOR ARCHITECTURE
BASEL BERLIN BOSTON

The publication of this book was made possible through the generous patronage of

Ben-Gurion University of the Negev
Mr. Edgar de Picciotto
Mr. Harold Oshry z"l and Mrs. Claire Oshry
Mrs. Rosalind Henwood

and through the additional support of

Rotbart-Nissim Structural Design, Ltd.
H.R.V.A.C. Consulting Engineering Co., Ltd.
Israelight Ltd., Architectural Lighting Design
Landmann Aluminium, Ltd.
Uri Doron Project Management, Ltd.
Ashlil Constructing & Investment, Ltd.
Extal, Ltd.
Segal Carpentry
Beta Acoustic Technology, Ltd. / Saint-Gobain Decoustics AG
Seviva Yeruka, Ltd.
Yosan, Ltd.
Alony Marble, Ltd.

Book design: Binocular, New York

A CIP catalogue record for this book is available from the Library of Congress, Washington D.C., USA

Bibliographic information published by Die Deutsche Bibliothek. Die Deutsche Bibliothek lists this publication in the Deutsche Nationalbibliografie; detailed bibliographic data is available in the internet at <http://dnb.ddb.de>.

© 2003 Birkhäuser – Publishers for Architecture
P.O. Box 133, CH-4010 Basel, Switzerland
A member of the BertelsmannSpringer Publishing Group

Printed on acid-free paper produced from chlorine-free pulp.
TCF ∞

Printed in Germany
ISBN 3-7643-6959-0

9 8 7 6 5 4 3 2 1 http://www.birkhauser.ch

CONTENTS

The completion of this book marks the end of a long and enriching process that began in the spring of 1996. We are deeply indebted to hundreds of wonderful people who provided help and advice and who were critical to both the building of the life sciences project and to the making of this book.

We are grateful for: the ever-energetic Dr. Avishay Braverman, President of Ben-Gurion University, who propelled this work forward through his far-reaching vision and his encouragement; Mr. Edgar de Picciotto, who left an indelible mark on the project in all its phases through his insightful leadership and his generous contribution of time and resources; Mrs. Rosalind Henwood, Mr. Harold Oshry z"l and Mrs. Claire Oshry without whose support the building and the publication of this book could not have been achieved; the strong guidance of the project's many other decision-makers, including Dr. Israel German, Uri Doron, Pinhas Kedar and Marius Freiberg; the dedication of an army of un-sung heroes that brought the project to life represented by and certainly not limited to: Dani Dinari, Yigal Rabinovitch, Avitzur Benbenishti, Joseph Landmann, Natan Wigman and Shimone Moradian; the tireless and helpful staff at BGU, Noga Porter, Arieh Shur, Anat Bunker, Lana Shalit, Esti Pollack; the members of the office in Tel Aviv without whom this could not have been realized, particularly Ofer Arussi, Yasmin Avissar, Sharon Paz-Gersh, Ifat Finkelman, Duffy Half, Dror Hai, Nelly Kopit and Michal Shmueli; the helpful consultation of Ziva Freiman, Lois Sher, Elin Avery and Janet Inbar; the creative energy and keen eye of photographer, Hélène Binet; the inspired images of Amit Geron; the beautiful design work of Joseph Cho and Stefanie Lew; the patience and the critical vision of our editor at Birkhäuser, Ria Stein; and the sound advice and assistance of Yael, Gur and Michal Melamede, Stephen Sparkes, Amie MacDonald, Michel Debiche, Stanford and Jo Ellen Robins and Shirly Gilat Robins. Special thanks go to all our family members whose support and encouragement meant so much to us along the way.

PREFACE

Ada Karmi-Melamede
David S Robins

This book is about the thinking and making of a complex of buildings designed for research and study of the life sciences at Ben-Gurion University of the Negev, Beer Sheva, Israel. The project was five years in the making and represents a culmination of our work at the University that began with the campus master plan in 1993 and was followed by the design of the Faculty of Health Sciences before leading to the Life Sciences commission in 1996.

The buildings are presented here in reverse order – as if being revisited. One follows a trail backwards in time, first through images of the completed building, then through working documents, and finally through the initial free hand sketches that inspired the design. The work is presented in this order because only after a project is fully realized does it leave behind the process of its making standing for itself in its own right. Only at this point can one visit one's own work and become an observer and a critic simultaneously. Previous doubts re-emerge and others seem to find some peace. In this process, we tried to be neutral, open-minded and somewhat removed. We hoped to better understand the relationship between thoughts and forms and between architecture and our drawings that had envisaged the place.

The project is composed of three different schools for the Life Sciences that serve students and faculty with diverse needs and visions. It is an institution of competing ideas and agendas sharing an intellectual space, but also having to find common ground in the physical place. The spaces required for study, for research, for group learning and for public gathering are very different. What divided them seemed to be clearer than what united them. Yet their disparate identities had to face each other and settle down side by side, often sharing a party wall. Moreover, these identities had to converse with the existing architecture of the campus with its 1960s language of New Brutalism that had inspired an austere ethos throughout BGU. Somehow, though unrelated programmatically, its original pioneering mood was so overwhelming, so potent and so persistent that it seemed our architectural search should begin in the existing campus, and in the pulse of its forms.

The conceptual aspects of design are seldom inspired by programs, which, at their very best, quantify use without qualifying need. These concepts are to be found somewhere else and often far away. Needs are non-specific and hard to translate into measurable terms. They involve moods, they change and thus have no space-time requirements. They are often fulfilled accidentally in rooms without a name, in spaces perceived to be inefficient and non-functional. And yet, it is precisely these rooms that weave the connective tissue of built form.

In this particular building and in this particular location, searching for conceptual clues meant wandering through campus and looking backwards, not in anger and not in awe, without sentimentality and without cynicism. It meant recovering the relevant aspects of an "architecture of good intentions" and bringing them together with the needs and dreams of a different era. As with so much of our work, this translated into a general preoccupation with the public spaces through which the spirit of the place is transmitted. The challenge of the Life Sciences Buildings was to create a place of communication, mediating between opposites while remaining simultaneously unique and universal.

Key:

Life Sciences Complex [LSC]

Toman Family Department of
Life Sciences Building [TLSB]

Henwood-Oshry Life Sciences
Teaching Laboratories Building [HOTL]

de Picciotto Institute of Applied
Biosciences Building [IoAB]

AN INTRODUCTION TO THE LIFE SCIENCES BUILDINGS
Ada Karmi-Melamede

Context

BEER SHEVA Beer Sheva is the biblical city of "seven wells." The modern city sits at the fringe of the Negev Desert and, with 200,000 people, is the last major population center en route to the the port of Eilat on the Red Sea, at the Southern tip of the country. It is a city in and of the desert dominated by a hot and dry climate during much of the year. Heat and glare rule intensely from dawn to dusk. A thin, dusty, yellow layer of sand covers the ground and extends well off into the horizon. During the short winter season, the dunes disappear beneath lush and wet vegetation. Yellow turns to green, the air mellows, the sky clears and the harshness melts away. The cool relief of the evenings becomes sharp and crisp. Fresh color schemes change the entire surface of the ground.

On account of its flatness and isolation within the seemingly endless expanse of the desert beyond, Beer Sheva feels like a "frontier town". It is a city of extremes, of an infinite horizon, where shade, water and green are scarce and therefore cherished. Within a short distance from Beer Sheva's municipal borders, the city dissolves into an undulating carpet of brown hills where nomadic Bedouin communities reside during seasonal migrations through the local landscape. The tents of the Bedouin are the prevailing built forms, conveying a sense of transience and temporality to the land. The concrete envelopes of the university campus convey the opposite. Here, the structural members of the façades penetrate the terrain, cut deep beneath its surface and declare a sense of permanence and stability.

Ben-Gurion University is one of the fastest growing and most dynamic academic institutions in Israel. Located in the middle of Beer Sheva, the University has cultivated an urban scale and character from the outset. Today, after decades of urban sprawl and city expansion, the campus remains Beer Sheva's most conspicuous and vibrant oasis.

FIRST IMPRESSIONS My relationship with Ben-Gurion University started when I was appointed Campus Architect in 1993. I inherited a master plan designed by Avraham Yaski in the 1960s, which was based on the ideology of New Brutalism. At the time, this was the primary architectural language both in Europe and in Israel. In the desert and far from the central hub of the country, the plan provided a very literal architectural translation for the young and heroic aspirations of a nation in the making. New Brutalism represented a new beginning.

At that time, the campus was situated in the midst of a landscape of shifting sand dunes, with heavy buildings of rough textured cast in-situ concrete, with massive *brise-soleils* hung on their surfaces, and deep exterior access galleries stretching horizontally along their façades. These buildings cast long and deep shadows upon themselves, changing continuously throughout each day and with every new season. The pilotis, the arcades, the deeply layered façades and the tactile earthy materials together promoted a sense of place and security, satisfying a longing for firm roots. These architectural elements became the physical vocabulary of the campus.

Within the simplicity of the old master plan's grid lay the heart of the place, a succession of introverted green courtyards filling its voids and populated with students and faculty. The original designers paid great attention to detail as they sought to tame the effects of both the harsh glare and the dry heat. With time, the rough concrete surfaces weathered from the wind and the sand, and softened without losing their muscular and upright presence. The campus retained an aura of stark modesty reminiscent of Israel of the time. By the 1990s, however, the university was in search of a new identity and a new language of building suitable to a rapidly evolving region.

In revising the master plan, I wanted to respect the atmosphere of the earlier era and let it echo throughout the future expansion plans of the university. I felt that design decisions must be culturally compelling, transcending immediate functionality in the service of the campus at large and reflect the same attention to detail that was practiced in the past. As the first realized work of the new campus plan, The Life Sciences Complex at Ben-Gurion University is, in many ways, a summary of my response to the dialogue between old and new.

THE ORIGINAL MASTER PLAN The 1960s master plan set up a consistent geometric grid hierarchically ordered. The entire grid sits on an idealized flat plane stretched across the campus like a mathematical table, despite a difference in elevation of almost four floors from east to west. It created both a network of gridded circulation and a repetitive set of public spaces. The various academic disciplines were organized in a succession of small, introverted courtyards strung along a major axis. This order was kept throughout the entire length of the campus and did not transform when it reached the edges. The seam between the university and the city seemed to be intentionally diffuse.

The basis of the plan was to establish a primary longitudinal axis running the length of campus, and crossed at fixed intervals by secondary perpendicular pedestrian routes of smaller scale. Passing through campus, this axis was intended to link the city neighborhoods to the west and to the university's sport facilities to the east. This approach derived from the belief that the university played an important role within the city, and that the community at large benefited from the academic life centered within it.

These connections, however, never materialized. The roads along the university's boundaries became major traffic arteries that are dangerous and difficult to cross. As a result, the university gradually grew into an introverted pedestrian island with vehicular movement and parking along its periphery.

The main public square of the university forms the entry to campus and is tangential to the main longitudinal axis. The square supports the greatest concentration of student facilities – the library, the bookstore, the large lecture halls and the student union and dining halls. A giant, exterior room with many doors, the square remains a vast intersection that celebrates the crossing from one side to the other. The effects of scale coupled with the desert sun leave little place for stopping and lingering.

THE NEW MASTER PLAN As campus architect for Ben-Gurion University, I had to address two salient facts: Beer Sheva had grown from a town to a major regional center; the university had grown from a small school to a major institution with an ambitious plan for expansion. This growth entailed an adaptation of the existing master plan to a new scale and a new urban framework. With this in mind, I adopted the attitude that some of the principles of the original master plan should

be continued: the volumetric divisions of the built area, the height limit, the importance of pedestrian circulation throughout campus, and the concentration of vehicular movement on the northern edge. Additionally, it was essential that the new campus remain a green and shaded pedestrian domain *dressed* in concrete.

The primary deviation from the original master plan came in the reconsideration of the universal campus grid. The revised master plan maintains the discipline of the grid, but encourages greater freedom within it. Originally, the grid related to the optimal length of pedestrian circulation routes given both desired classroom capacities and fire egress laws. These criteria, in turn, determined the length of building blocks and, as a consequence, their volumes. The grid set up a fixed relationship between buildings and voids, and it defined the perimeter of each module. As a result, the two-dimensional grid created a measure of both distance and time. Together, these constituted a *pace* within the general fabric of the master plan.

Extended across the entire current campus as originally intended, the grid would certainly have become too monotonous. While it makes necessary daily connections efficient and orderly, it reduces the spontaneous ones; it limits chance encounters. I believed that the basic order of the master plan was strong enough to accept occasional interventions that would allow one's feet to wander through and across rather than along and parallel to the perimeter of each block. I thought to increase the movement options in plan and in section, and to diversify the spatial experience by diverting the perspectival views and widening the angles of vision.

The new plan attempts to create spaces of individualized identity rather than repetitious ones. It calls for complex building sections along the periphery of the campus that can address and relate to the various urban scale issues confronting these edges.

The new master plan extends the major axis eastward toward the railway station. Connected by a pedestrian bridge and promenade, the train station will become a new gate to campus of a regional scale and character joining the university to the country at large. This will shorten the physical and psychological distance for those who live in the north.

The new master plan introduces a diagonal axis that connects the Faculty of Health Sciences to the south, through campus, with the university's reservoir of land to the north. The diagonal geometry of this axis penetrates the grid and creates a dynamic spatial progression all along its route in the form of

a series of wedge-shaped spaces in plan. These are treated as secondary public plazas where one's relationship to the surrounding buildings is never static thus creating a natural spatial progression. The changing angles of vision and relative distance provide greater orientation and sense of place.

The new master plan carves into the earth and creates a sub-level open to the sky. This compensates for the conflict that arises between the existing restrictions of building heights that were formulated to give the campus a uniform skyline on the one hand and the large amount of area required in long-range planning forecasts on the other. Moreover, the new series of sunken gardens are designed to offer more pleasant and sustainable microclimates as well as softer light. I intend that these spaces offer a richer variety of views from which to engage the vertical layering of campus. Opportunities for a more complex three-dimensional circulation pattern emerge as people move on various levels through a sequence of garden courtyards more remote from the campus center and, as such, more intimate and personal.

The Life Sciences Complex

A LITTLE CHAOS – A LITTLE ORDER Composed of three buildings, the siting of the Life Sciences Complex is of great importance. It faces the entry to campus from a major city street and occupies a part of the street façade. As such, the project is both of an urban dimension and part of the campus fabric. It is bisected by the north-south axis which links both the Faculty of the Health Sciences and the BGU student dormitories to the south of campus with a large parcel of land for future university development to the north of campus. Thus, the complex is located at a critical junction where different activities and scales of buildings converge. Within these circumstances the Life Sciences Complex must assert its own identity.

The outdoor spaces of the complex are elongated, contained and clearly defined. They connect to the existing gardens to the west, establishing a sequence of sunken, protected and sloping public spaces that allow for a dynamic spatial experience. New connections of various scales develop between the inclined topography of the gardens and the existing campus levels characterized by a pleasant microenvironment. The sloping terrain within the central garden behaves as a plane of reference that pulls the pieces together and accentuates the sense of arrival and departure. It forms the

underlying basis of a larger order that juxtaposes the different buildings and maintains the tension between them. The space of the courtyard seems to close upon itself but it is, in fact, open at either end. Entry to and exit from the project occur at its somewhat obscured corners, which are discovered *en route*. In this way, the central space of the complex acts as a fragment of the larger system of campus spaces beyond.

THE IN-BETWEEN The complex is composed of related programs requiring a large percentage of highly technical rooms such as laboratories, support rooms, plant breeding rooms, computer labs, seminar rooms, offices and even a large greenhouse laboratory (see page 131). The three university faculties that comprise the project (the de Picciotto Institute of Applied Biosciences Building [IoAB], the Toman Family Department of Life Sciences Building [TLSB], the Henwood-Oshry Life Sciences Teaching Laboratories [HOTL]) sit atop a common basement with a shared infrastructure. The lobbies and the general circulation areas face an inner courtyard, offering a network of opportunities for observation and communication. They constitute the public forum that is so vital to the collective lives of the users.

Voids between buildings are more permanent than buildings; they are of the public realm and have a long life span. I regarded the voids within the buildings (i.e. the internal public spaces) and those without, as a continuous system. One could conceive of a dialogue between them—a dialogue that is realized through a sequence of spaces that travel vertically and horizontally, in plan and in section.

This spatial sequence was designed as a continuous and hierarchical one, visible from one segment to the next with the gap between outside and inside diffused and the options for communication increased. We orchestrated a volumetric chain of public rooms — from interior, introverted quiet places to exterior, dynamic ones. These public domains penetrate each of the three buildings and extend beneath the ground plane. In addition, a series of ramps, walls, bridges, stairs and rooms resolve the primary geometries and sight lines of the buildings while the voids they create in their interaction express entry, observation, procession and repose. This continuum intensifies the feeling of being part of both the life sciences community and the university as a whole.

The hierarchical differentiation of these spaces is further complimented by changes in material and workmanship. The

14 use of a stark and minimal palette of materials employed outside including concrete, stainless steel, glass, and stone, changes for the interiors. Access galleries, railings, stairs and benches of wood, stone, plaster and stainless steel are elaborately detailed and crafted. They are specifically designed to match both their location and the sequence of adjacent materials and forms.

A NEW TOPOGRAPHY The sloping courtyard dominates the interior architectural life of the project. The courtyard begins at a tight juncture of two buildings, slides down and terminates in a broad public area. Because it splays in plan and shifts in section, the space created by the courtyard is complex. The building volumes are pushed close together, forming a natural barrier to the southern sunlight. Diffused light bounces off the concrete walls, eliminating the glare characteristic of the surrounding desert. Together with the simplicity of both its "green" surface treatment of simple foliage and its water element the space feels serene and dynamic at the same time.

At ground level the courtyard is flanked by an open arcade on one side that looks directly into the Institute of Applied Biosciences laboratories and an elongated gallery on the other that displays the results of current research of the Life Sciences Department. Pedestrians moving along these routes may view the work of the scientists inside without disrupting them. The transparency and interaction promote a sense of community and belonging.

The change of grade of the interior courtyard affects one's perception of the campus beyond. Buildings outside the complex are suddenly observed from below; they appear taller and their horizontal layering is more evident. By manipulating the ground plane, the movement through the buildings which relates to "getting somewhere", and the wandering of the eye which relates to "taking it all in", assume different routes. The path of one's feet and the journey of one's gaze are constantly encouraged to be independent of one another. In this way, the project's architecture is revealed through long journeys of the eye and shorter ones for the feet. This coexistence allows for a flexible itinerary and for chance encounters as one moves from place to place, level to level.

HITTING THE GROUND Reinforced concrete is the primary building material in Israel, used mostly for the structural skele-ton, and rarely exposed as a finished material. Yet the majority of buildings on campus executed in the 1960s and 1970s used cast in-situ concrete formed in wood shuttering. We chose to rely on concrete as our primary and exposed building material because it serves to unify the language of the old and the new and, when detailed intelligently, performs well in the desert climate.

In the 1960s, the use of *beton brut* was linked to an ideology, partly influenced by the arts and crafts movement before and partly by the social conscience of the architects of the time. They aspired to create a universal architecture, one defined more in terms of ethics than in terms of aesthetics. Architecture, in their view, was to be place-oriented and more specific. As a result, the buildings on campus are functional, austere and responsive to climate. Each floor was expressed through pronounced grooves of different sizes and depths. The means of construction, the joints, the length of each pour left their marks on the elevations.

The vertical layering of the façades was real, not illusory. One could occupy the space in between the layers, and inhabit the voids. The architects understood the language of concrete, its properties, its production process and the role of the human hand. Their concrete looks personal and crafted — not prefabricated.

Whereas earlier casting was carried out with wooden form-work, today a majority of finished concrete formwork is framed in steel. This leaves the imprint of each panel on the finished surface, which we consider to be a somewhat arbitrary abstraction. We overcame this by minimizing the vertical seams and exaggerating the horizontal ones. We felt that the continuity and the coarseness of the wall needed to be retained, that it should remain heavy, load bearing and protec-tive — a wall that one could lean against. The need for defined and introverted places seemed to persist. The use of light and shadow enriches these places by increasing the empathetic depth of the wall.

The vertical expression of the walls is consistent through-out its concrete envelope. The arcades, which face onto the green courtyard, have a repetitive and uniform pace matching the same rhythm on the opposite façade. But the sloping stairs, the inclined topography, the ribbon window and the exaggerated geometry in perspective — all these elements promote horizontality. The confrontation between the vertical

and the horizontal expression dominates the courtyard. Its space is simultaneously engaged and released, restrained and relaxed.

On the southern façade, the concrete walls of the de Picciotto Institute of Applied Biosciences are articulated as load bearing; they descend heavily toward grade. Long protruding elements are hung upon the façade wall shielding the glazed surfaces of the laboratories behind from heat and glare. These are made of matte stainless steel fins, with horizontal milky glass louvers. Set in a row, they create a formal edge to the campus with a pronounced urban rhythm and scale.

In contrast, the internal walls of the complex are lighter and more transparent. They face onto the courtyard and their surfaces are far more articulated. From the grooves between the concrete pours and the structural floor slabs, to the framed windows and the shaped columns, the garden façades convey a scale directly related to the occupants within.

Within the same courtyard, one wall extends horizontally towards the campus beyond and the other stretches vertically to the sky. One delineates and shields an internal corridor and the other creates an outdoor arcade for sitting and strolling. The conflict between these formal expressions promotes a consistent, asymmetrical and dynamic balance within the courtyard.

CONCRETE The final expression of finished concrete testifies to the way in which it was fabricated, mixed and formed. The type of shuttering, the tie rods and size of each and every panel are marked on its face. The elevation is both structure and envelope, often undistinguishable from each other.

We were interested in both the plastic properties of concrete and the discipline of its means of production. Our walls tell the story of their making and describe the inner order of the building. There are windows that protrude, windows that recede and free standing glass curtain walls that bypass the concrete floor slab. Concrete can therefore be understood both as a load bearing material and as a thin membrane.

Concrete seems *moody* in winter when it gets wet. It comes to life on sunny days and gets *angry* under cloudy skies. The use of stainless steel and glass both tempers and lightens these moods. These materials promoted a sense of precision and delicacy that concrete could never achieve by itself — a contrast between rough and smooth, man made and machine made.

Concrete weathers well in the desert. With time, its texture softens and its dark gray tones become slightly gilded due to the sand blasting effect of the desert winds. The face of the building is constantly changing and its "age" is legible through its color. The face of concrete depends on a strong relationship between technology and craft. It belies the means of construction, time and order.

LIGHT Light is often brought into the building in an indirect manner so as to diminish both its intensity and the impact of its glare. Window "frames" relate to the different exposures. On the southern elevation, we use four-story tall stainless steel window surrounds to shade the glass and bounce light backwards. On the northern elevation, we changed the shape of the fins such that the western exposure is protected by opaque stainless steel and the northeastern exposure captures the morning sun. On the eastern elevation, tilting the frames towards the north reduced both southern light and reflections.

All these adjustments make for more pleasant living and working environments. Indeed, even the interior courtyard becomes a unique space where you can spend most of the day, even at the height of summer. Here diffuse light filters down into the working spaces below grade where we have cut open the building section.

WHEN ALL IS SAID AND DONE Programmatically, historically, geographically, The Life Sciences Complex serves many clients. We tried to find a balance between the written program that conditioned the design process and the unwritten need that inspired it. In considering all of them, the building has become a place that is many things simultaneously. It is neither a pure object, nor a pure fragment but a mixture of both that contains their conflicting properties. It is therefore not homogenous.

The space of the complex is both still and tense, confined and released, public and private. It has rooms for gathering and rooms for contemplation. It promotes many associations and relies on the technology of today while celebrating and incorporating the craft of yesterday. The Life Sciences Complex is a hybrid that maintains the conflict between old and new, specific to a place and time and, I hope, relevant for the years to come.

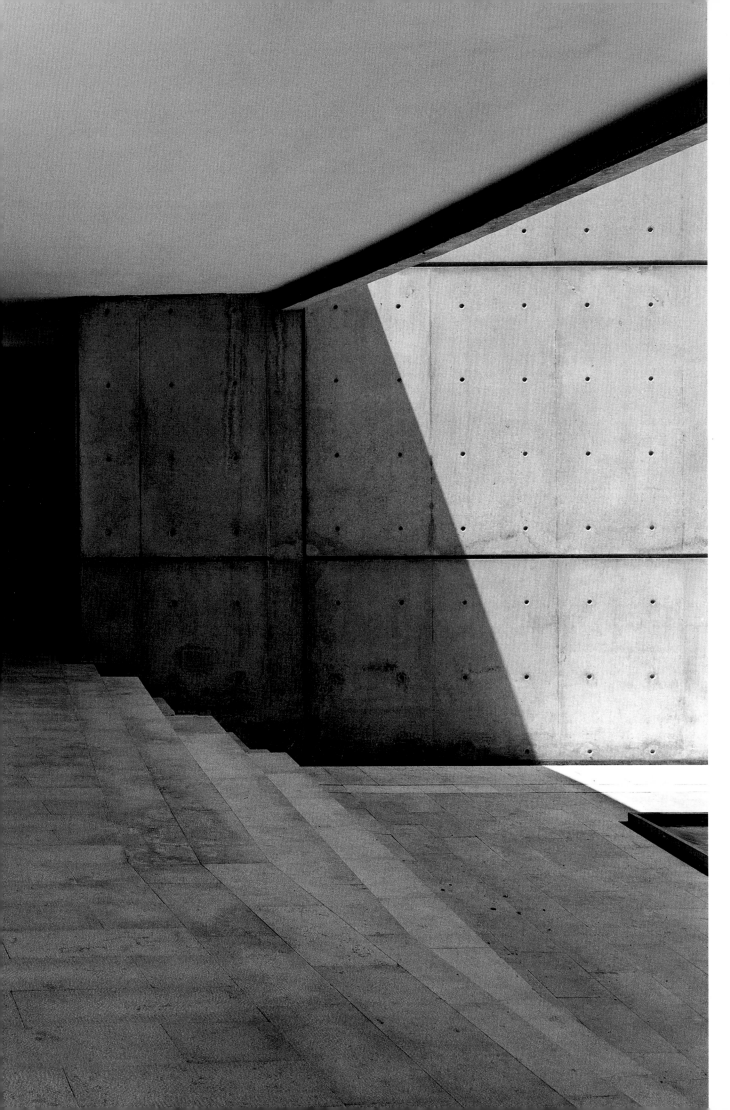

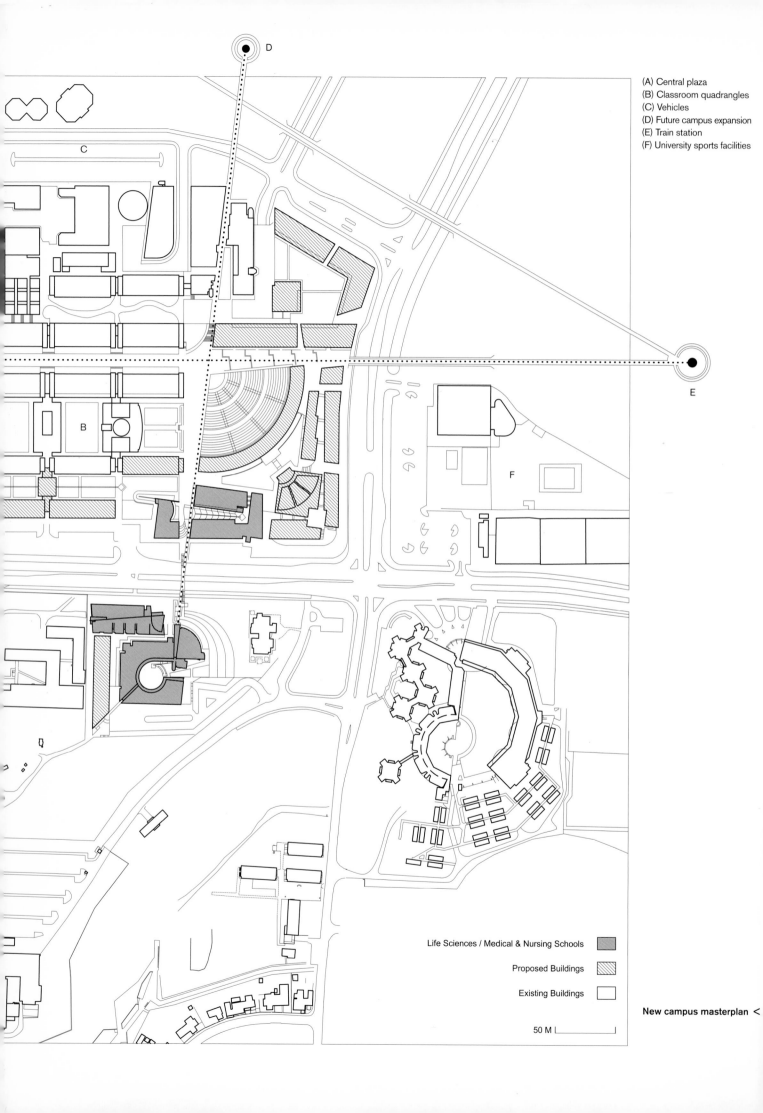

(A) Central plaza
(B) Classroom quadrangles
(C) Vehicles
(D) Future campus expansion
(E) Train station
(F) University sports facilities

D

C

B

E

F

Life Sciences / Medical & Nursing Schools

Proposed Buildings

Existing Buildings

New campus masterplan <

50 M

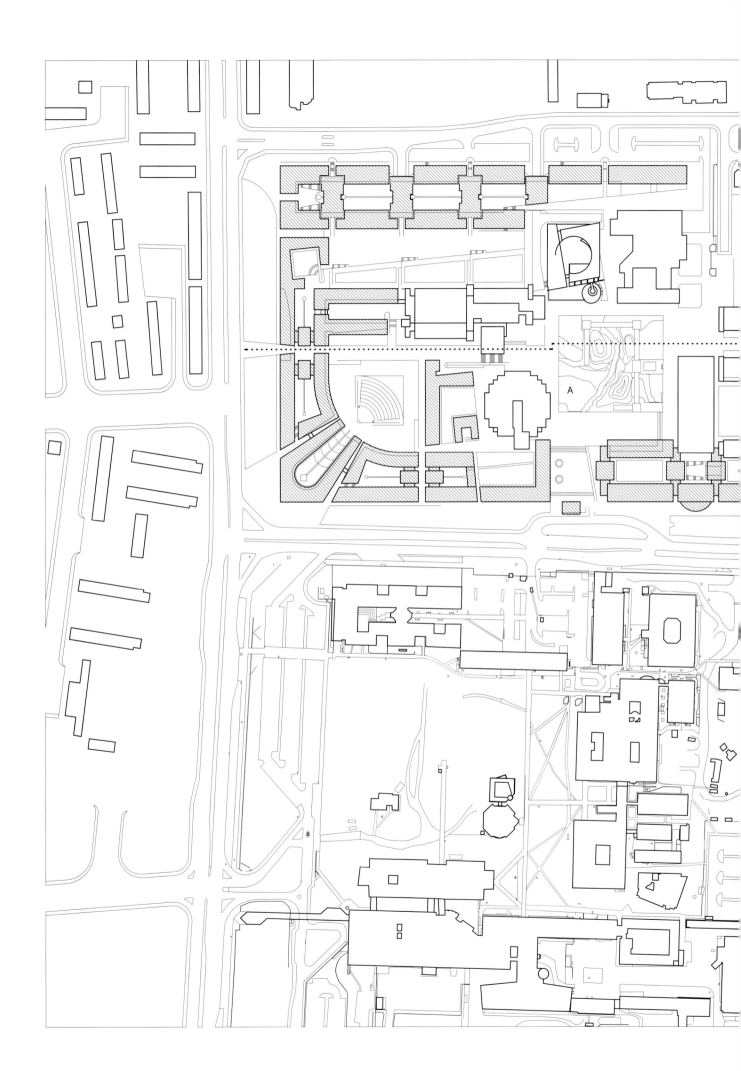

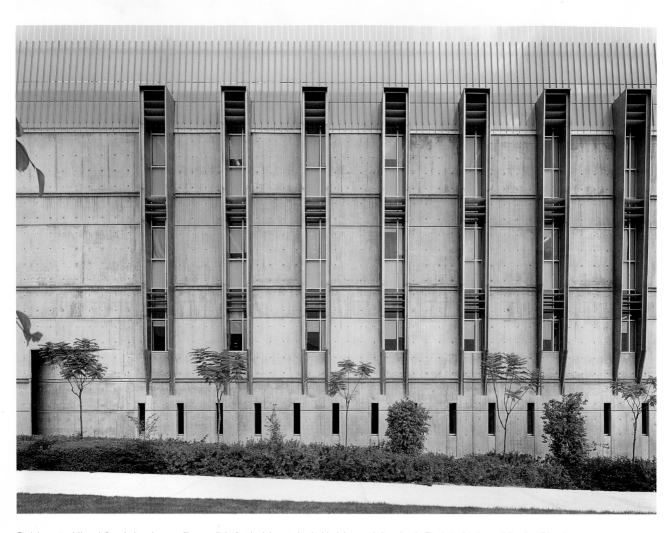

Stainless steel "hoods" and glass louvers filter sunlight for the laboratories behind the south façade, de Picciotto Institute of Applied Biosciences.

Documentary drawing >

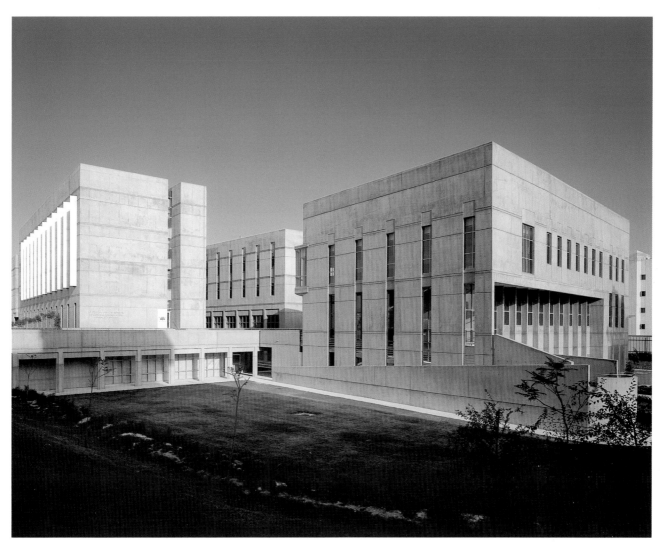

Life Sciences Complex as seen from campus plaza to the northwest.

< Documentary drawing

Southern façade in detail, de Picciotto Institute of Applied Biosciences. >

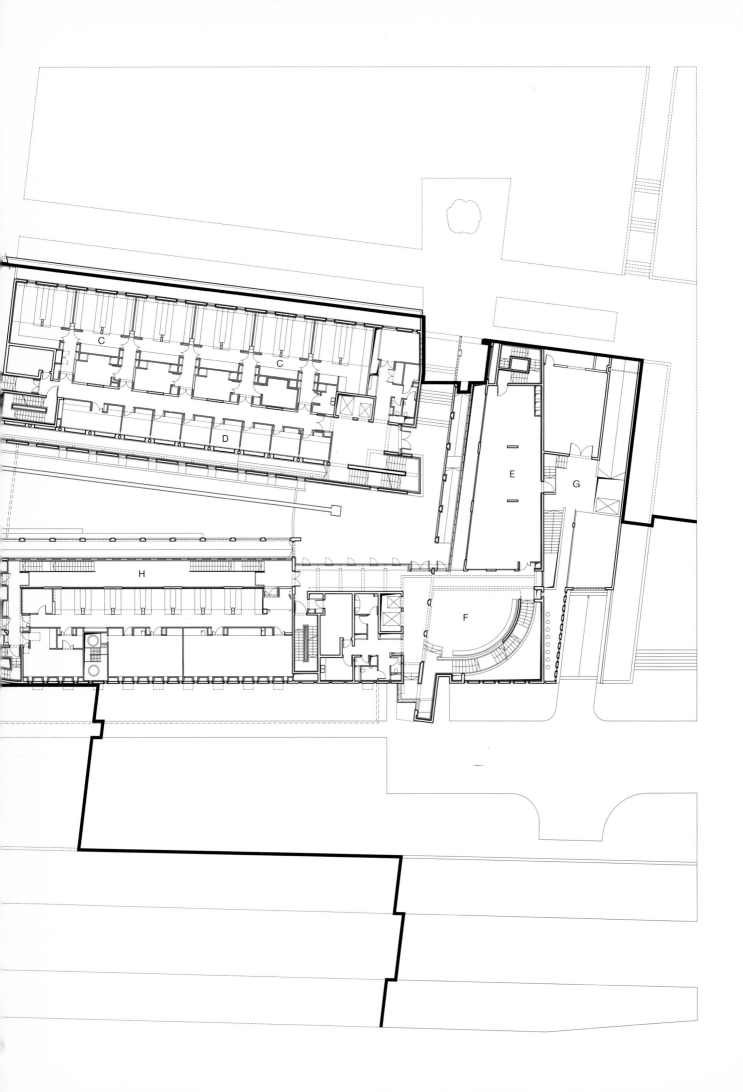

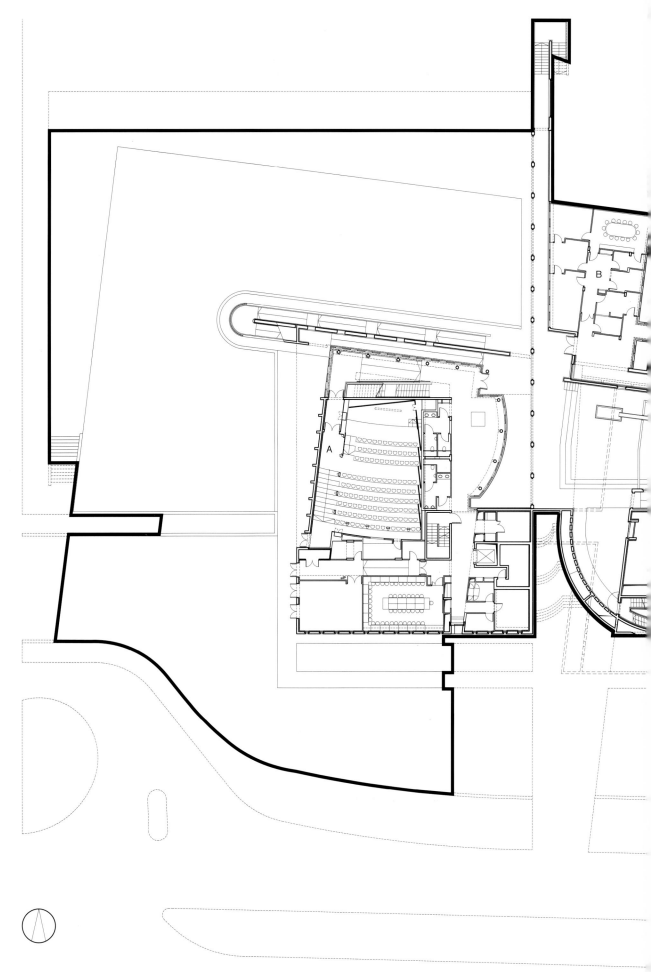

(A) Lecture hall
(B) Administration
(C) Research labs
(D) Offices
(E) Future expansion
(F) Greeting hall
(G) Services
(H) Equipment center

> Garden level plan

⌐_____⌐ 10 M

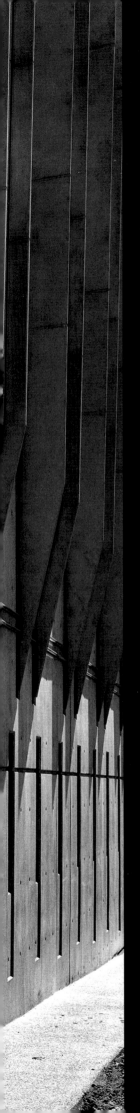

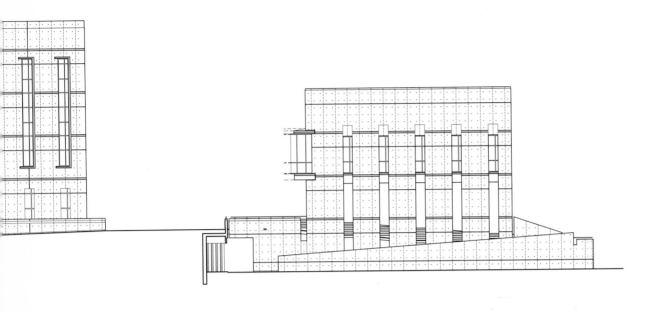

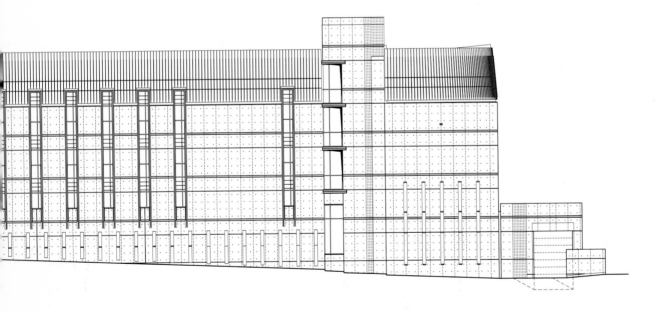

1. North façade <
2. South façade

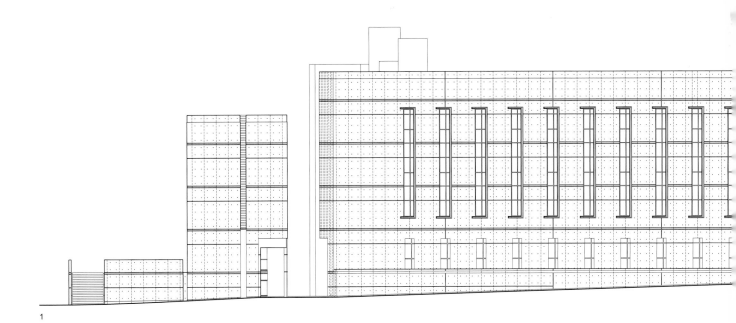

1

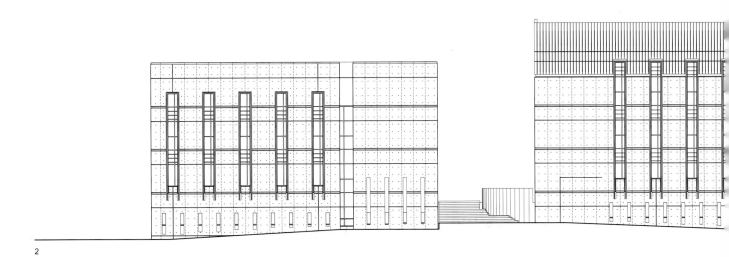

2

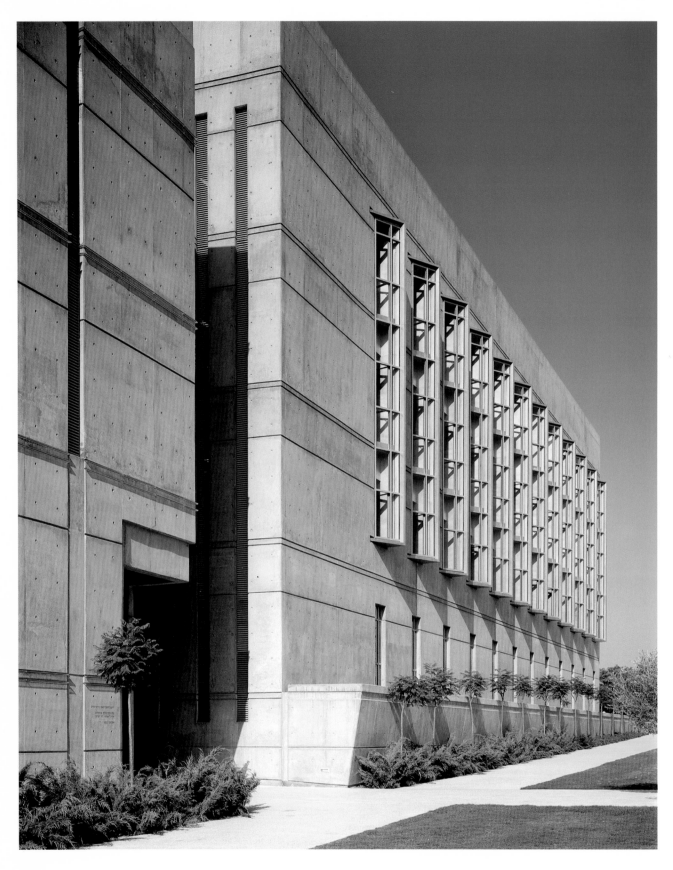

Laboratory windows on the northern façade of the Toman Family Department of Life Sciences Building pivot outward to face northeast.

Documentary drawing >

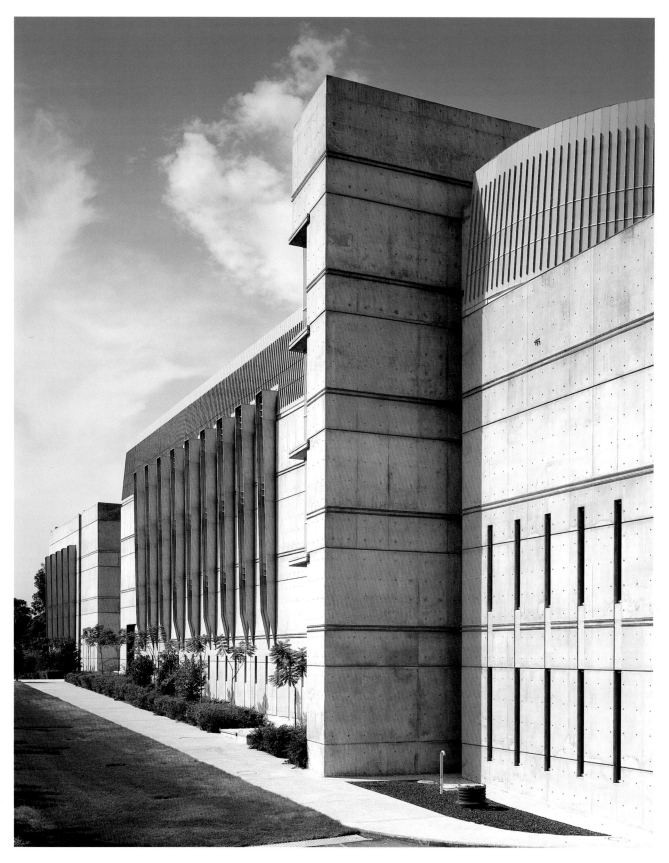

The southern façade along Ben-Gurion Boulevard is the public face of The Life Sciences Complex.

< Documentary drawing

Stainless steel window boxes reflect the late afternoon sun along the northern façade. >

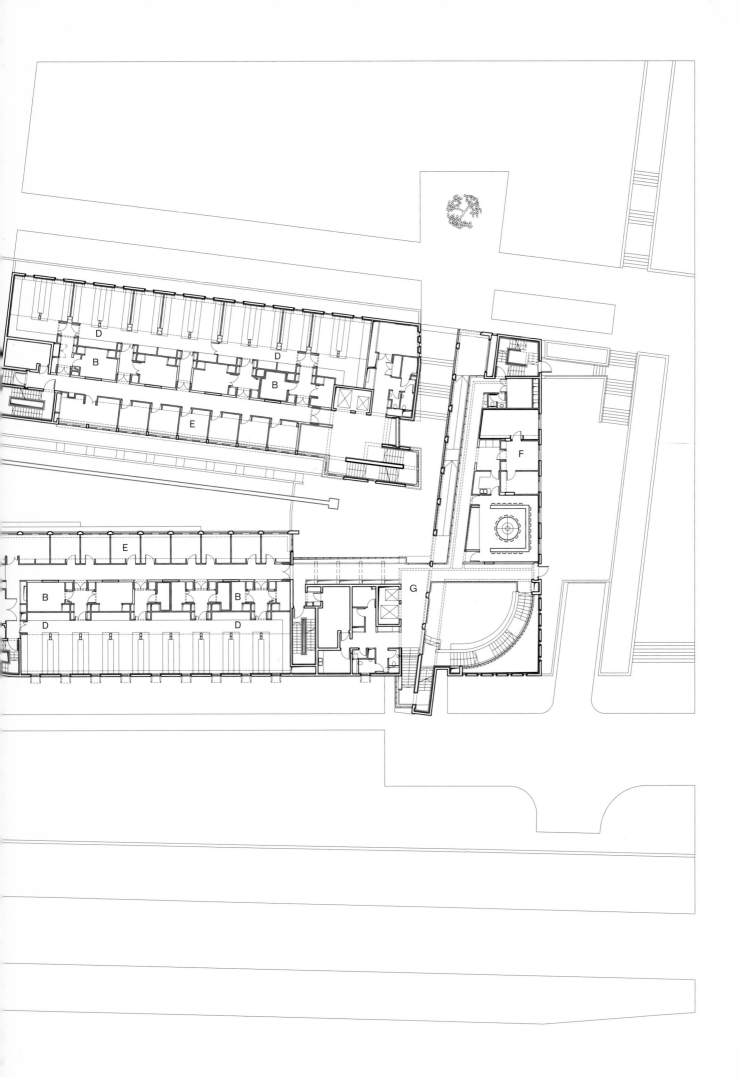

(A) Teaching lab
(B) Laboratory support
(C) Student lounge
(D) Research labs
(E) Offices
(F) Administration
(G) Mezzanine

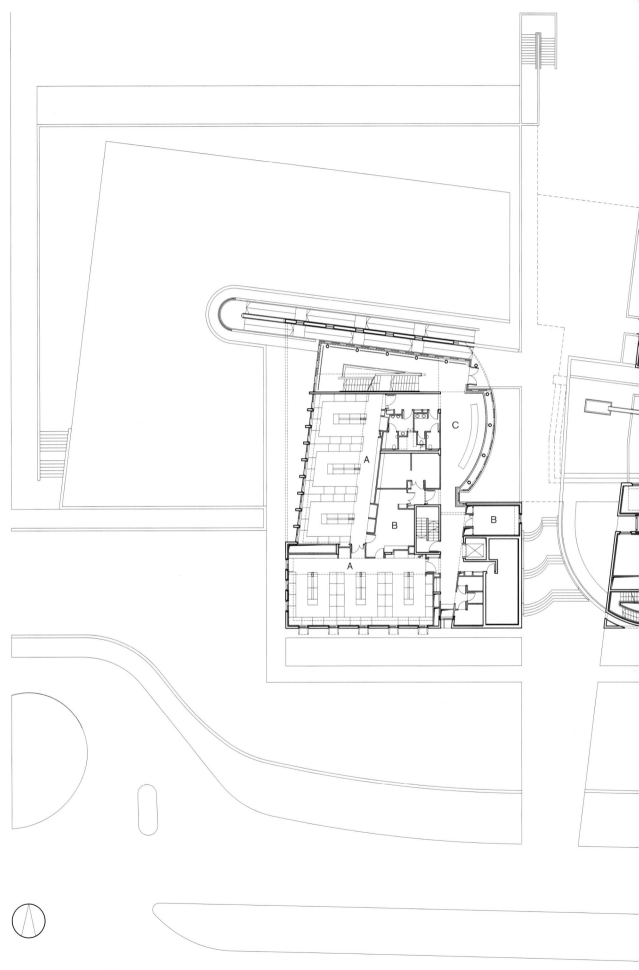

> **Campus level plan**

10 M

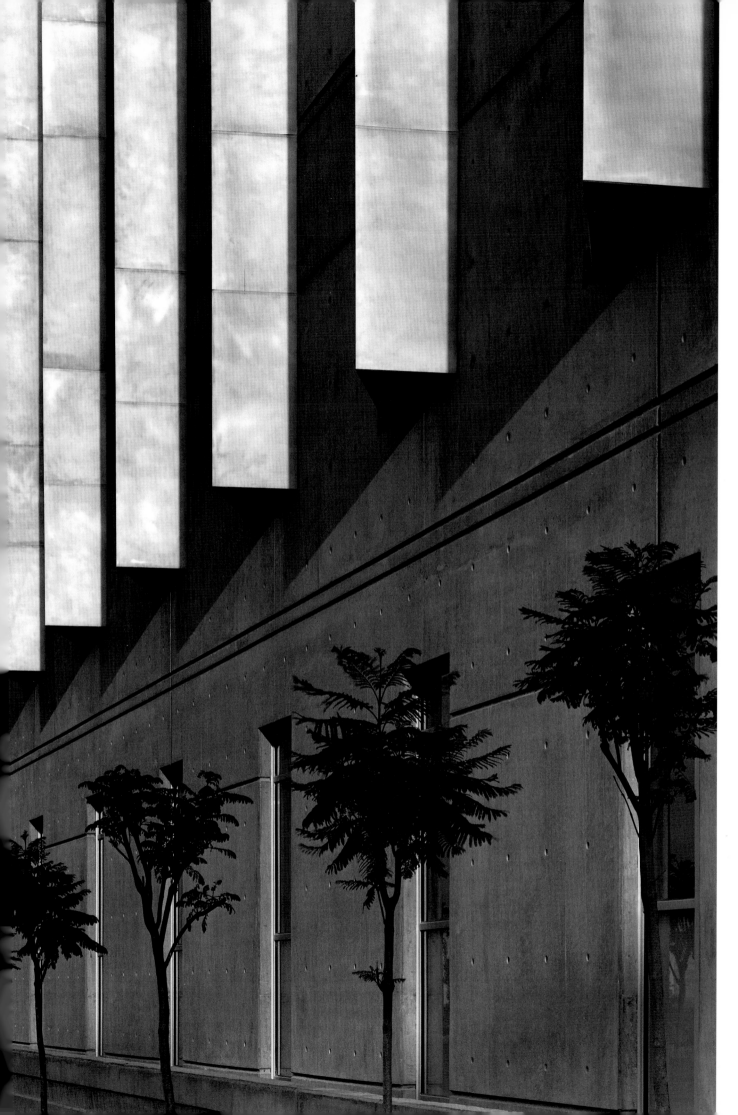

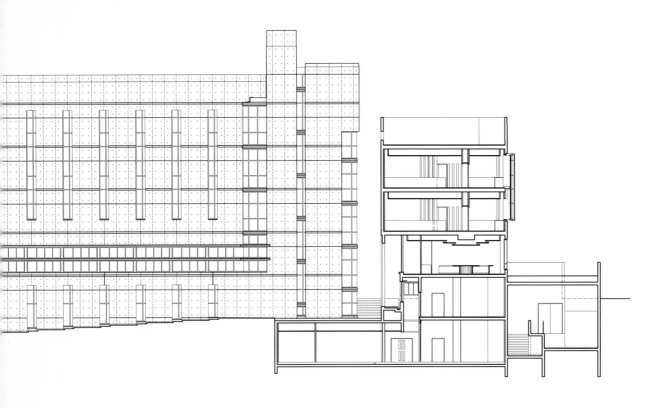

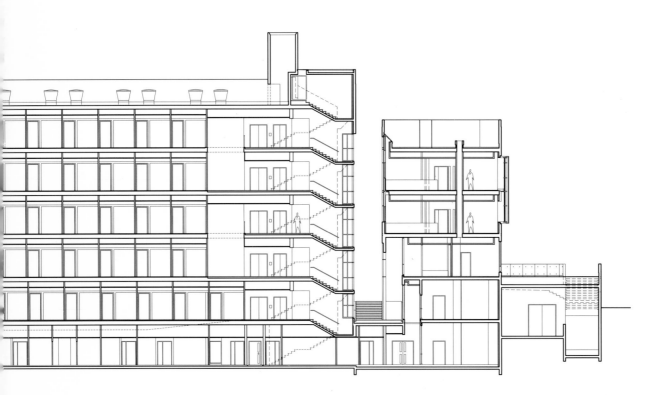

1. Interior south façade <
2. Longitudinal section

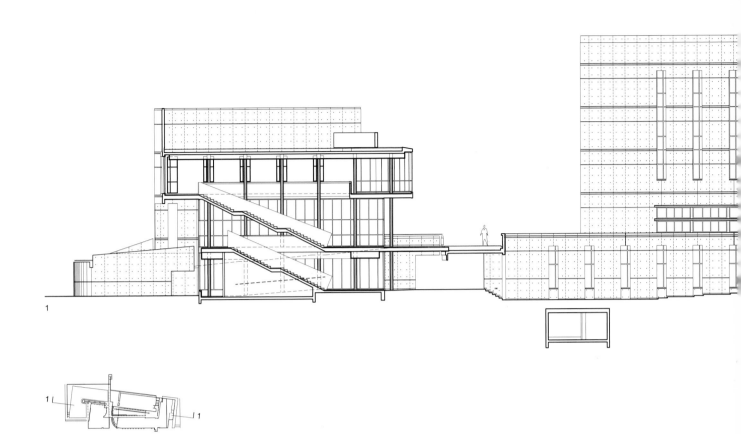

1

1

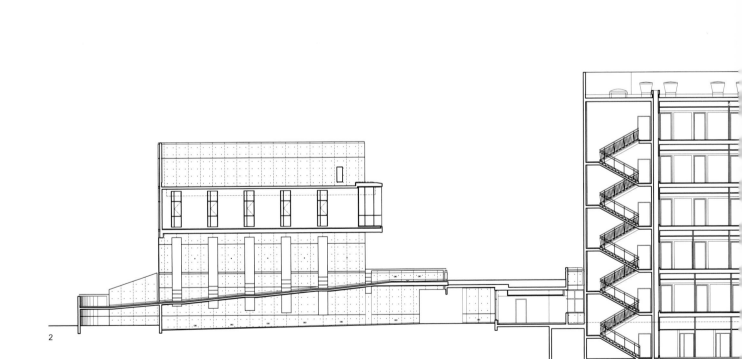

2

2

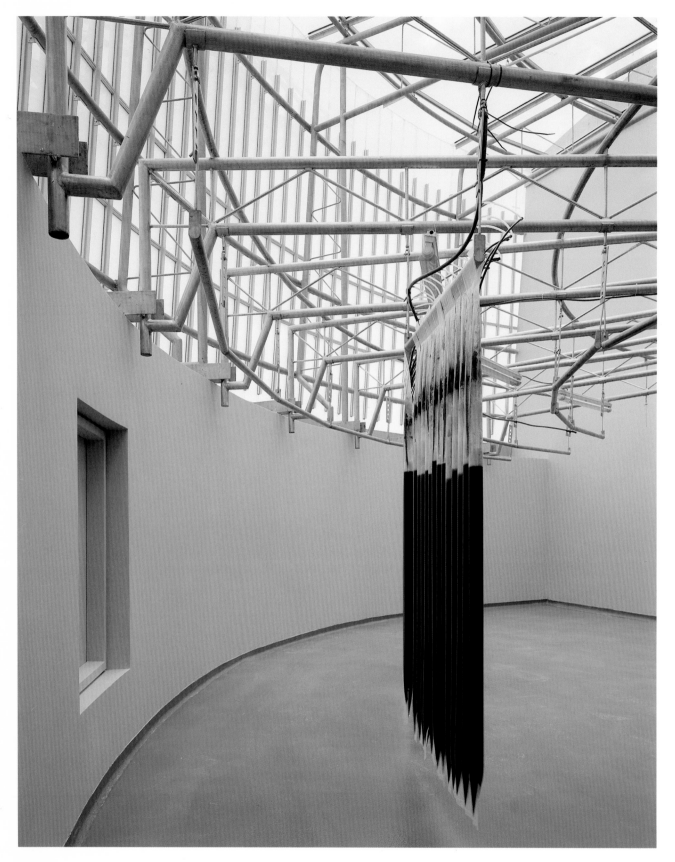

Researchers currently use the greenhouse laboratory at the top of the de Picciotto Institute of Applied Biosciences for the study of algae genetics.

Documentary drawing >

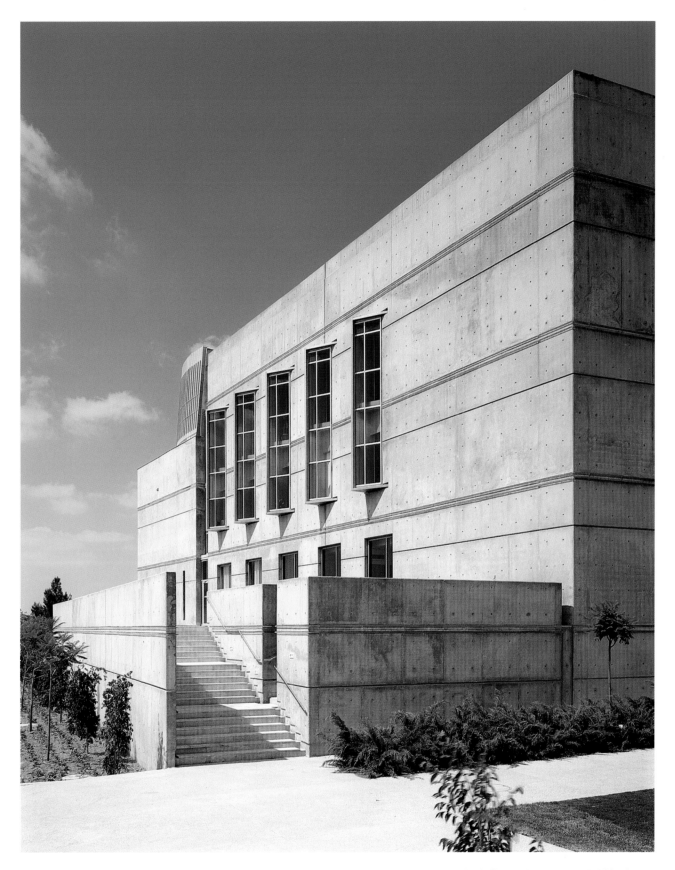

Steps to terrace garden at base of eastern façade, de Picciotto Institute of Applied Biosciences.

< Documentary drawing

Stainless steel substructure holds a curtain of translucent
glass panels enclosing the greenhouse laboratory. >

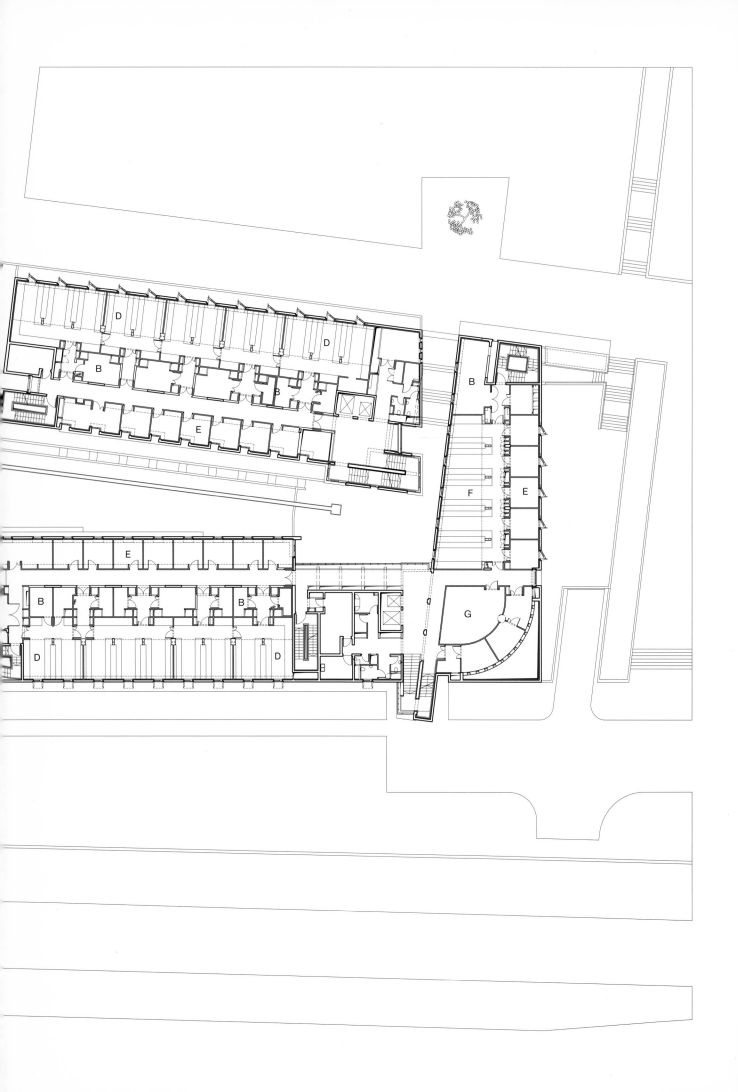

(A) Teaching lab
(B) Laboratory support
(C) Student lounge
(D) Research labs
(E) Offices
(F) Group research labs
(G) Specialized labs

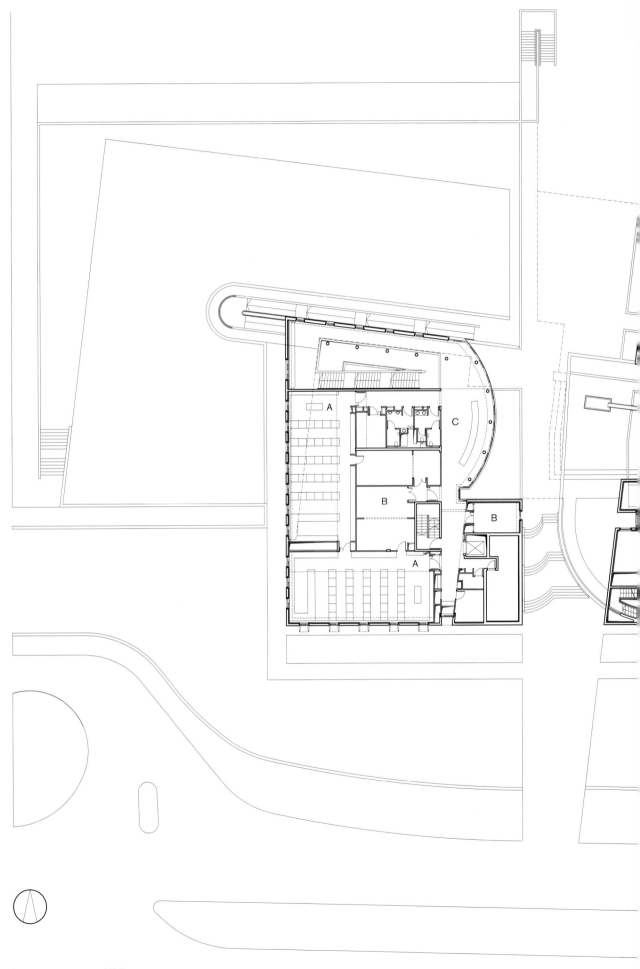

> **Second level plan**

|_____| 10 M

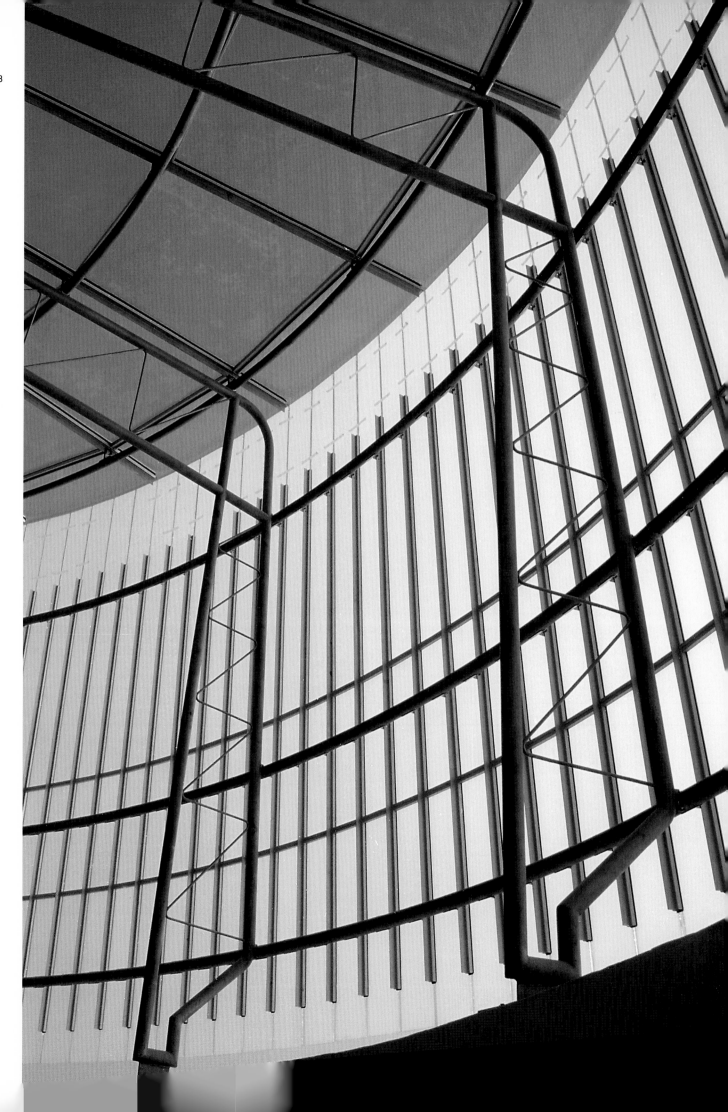

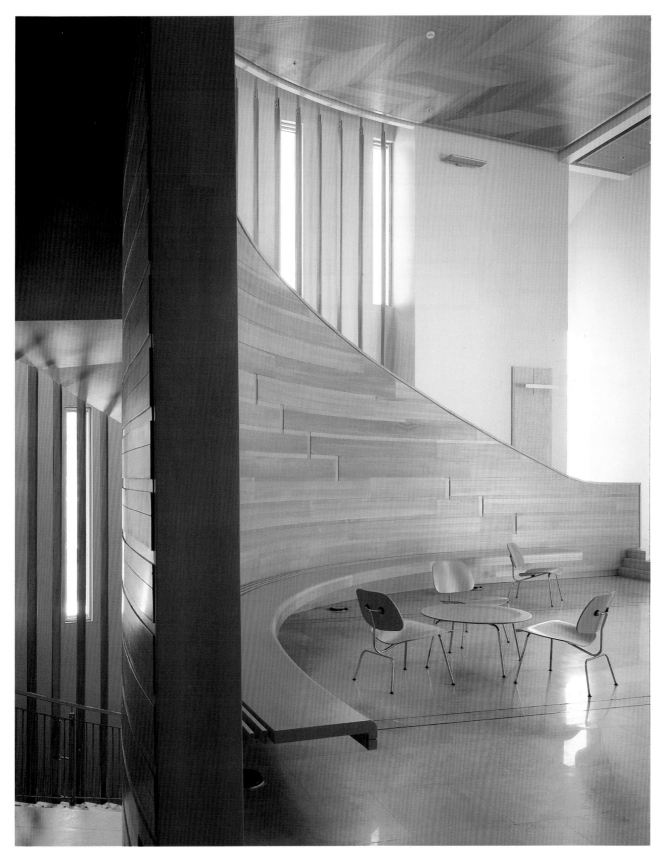

Greeting hall, de Picciotto Institute of Applied Biosciences.

Documentary drawing >

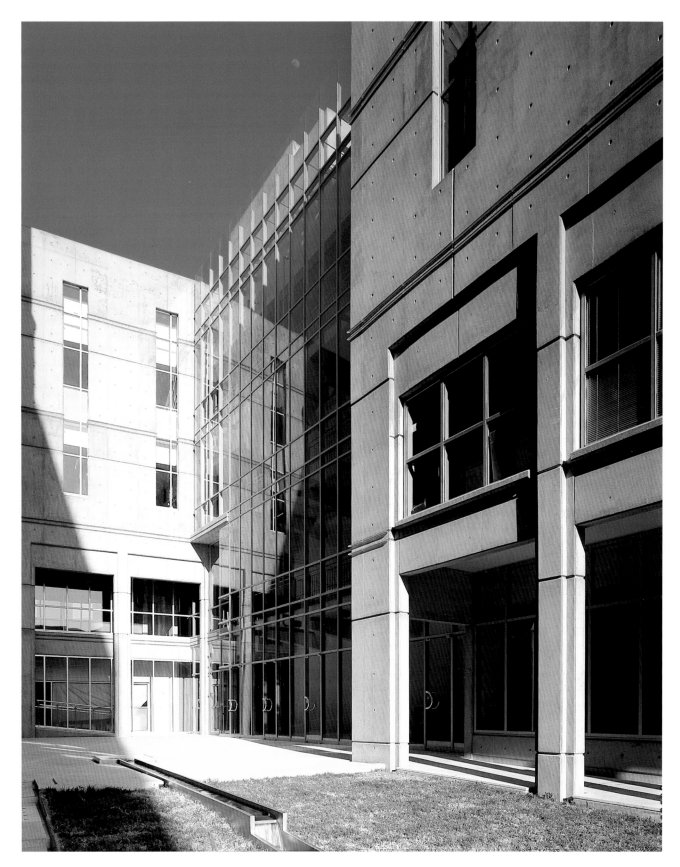

View of upper courtyard, de Picciotto Institute of Applied Biosciences.

< Documentary drawing

View of inner garden from upper courtyard. >

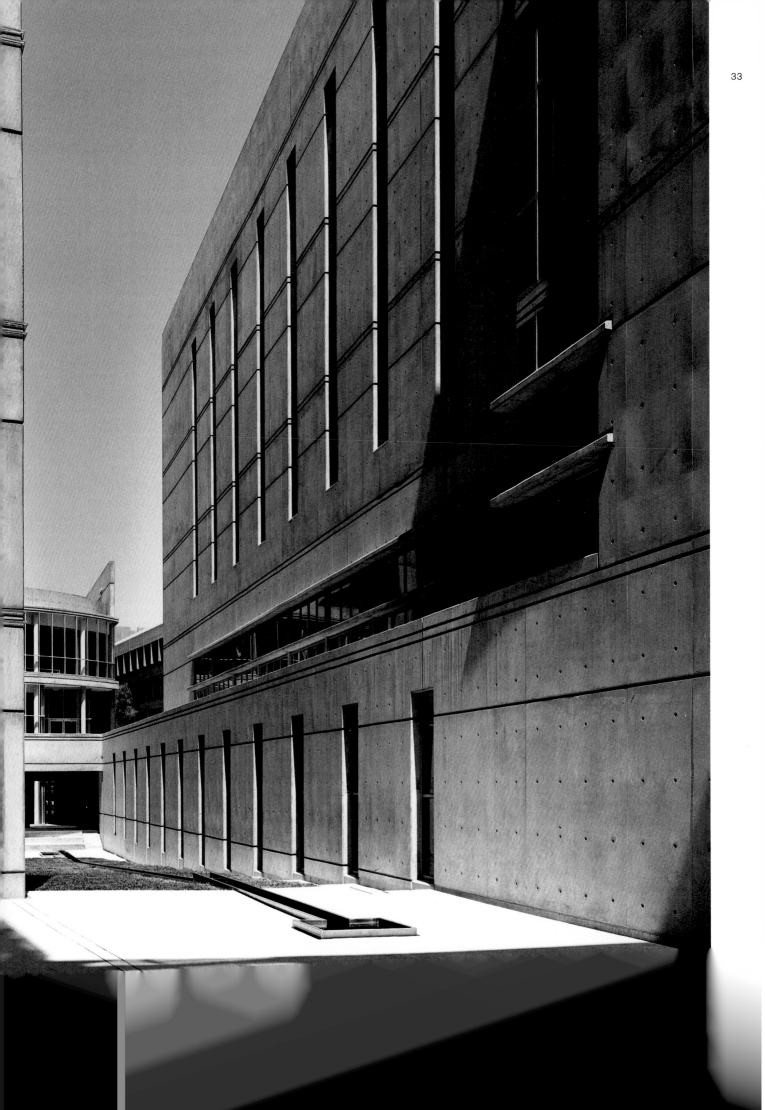

34

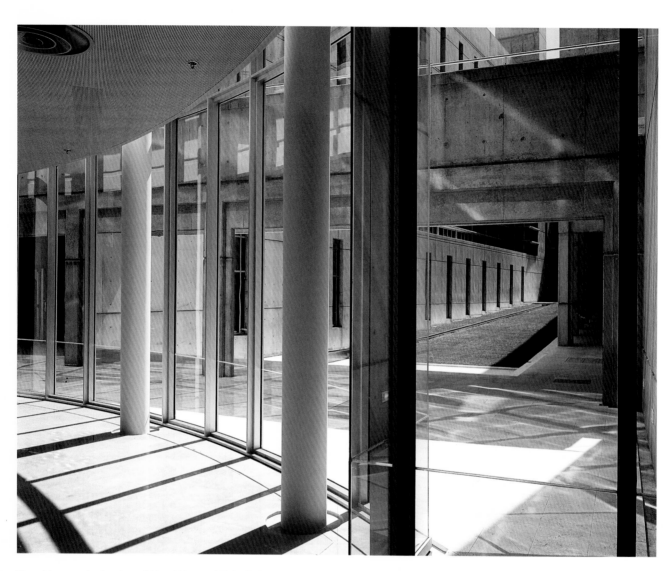

View of inner garden from lower lobby of Henwood-Oshry Building.

Documentary drawing >

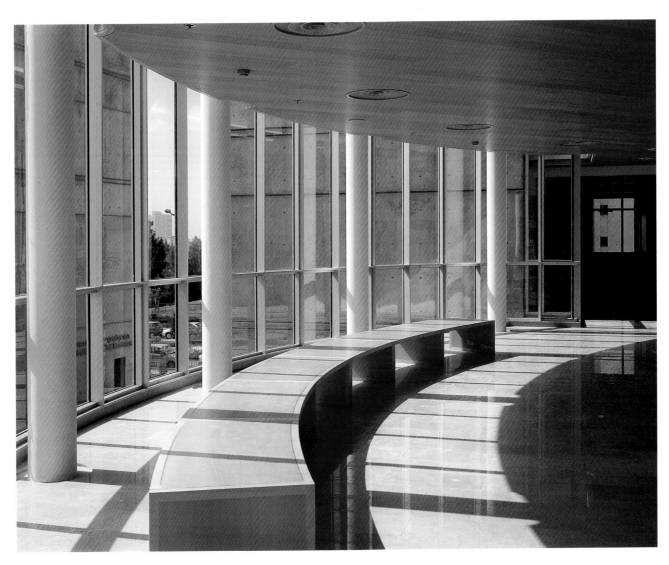

Lobby spaces with views to the inner garden function as student lounges directly outside the teaching laboratories.

> :
:

< Documentary drawing

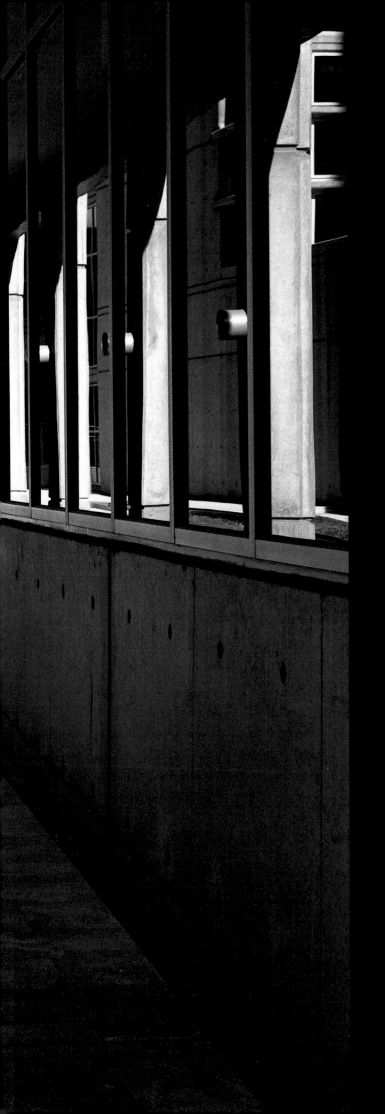

South-facing interior garden façade, Toman Family Building.

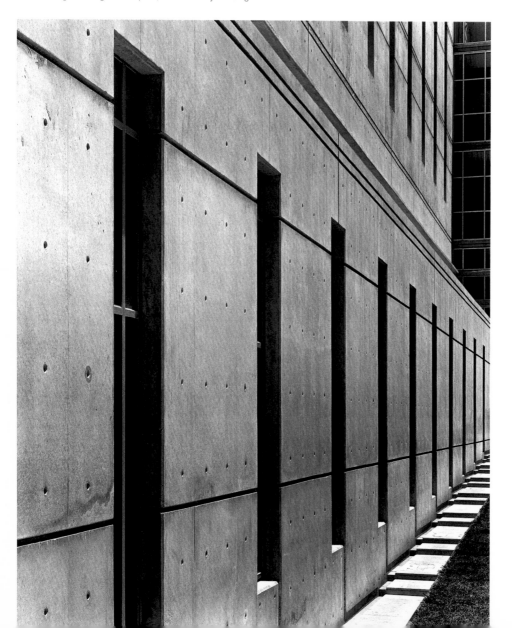

Construction drawing >

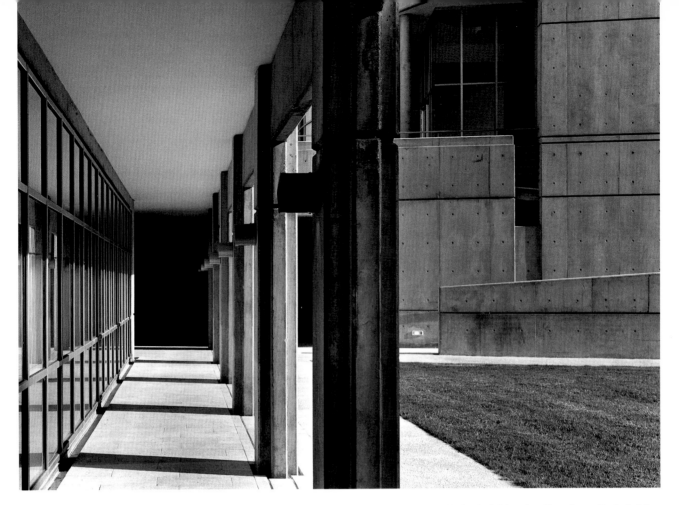

Arcade shading western façade of garden level administrative offices, Toman Family Building.

< Construction drawing

View of entry bridge to Henwood-Oshry Life Sciences Teaching Laboratories. >

Partial view of north façade, Henwood-Oshry Building.

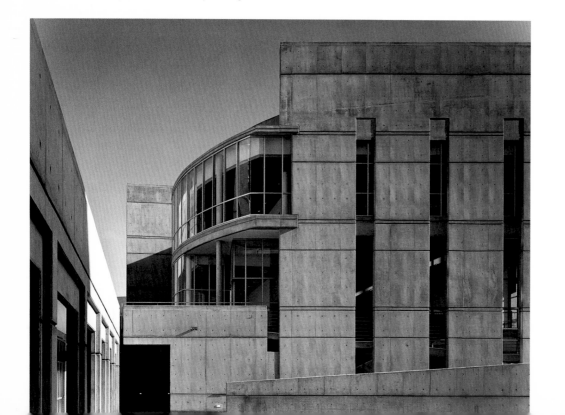

Construction drawing >

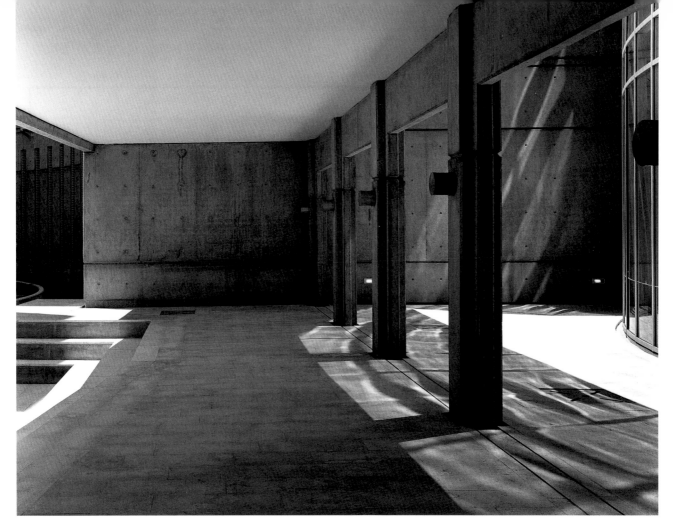

For the exteriors, the basic palette of building materials included bush-hammered stone paving inset with glass and lightly colored plastered ceilings.

< Construction drawing

Ramp ascends from sunken botanical garden to level of main campus. >

Water cascades down slope of central garden in narrow flume fashioned from stainless steel.

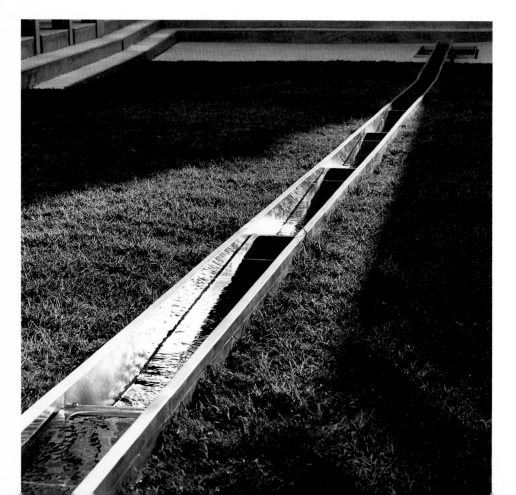

Construction drawing >

Stone flooring detail: narrow recessed channels separate both vertical walls and parapets from the primary horizontal surface.

< Construction drawing

View westward of central garden from group laboratories. >

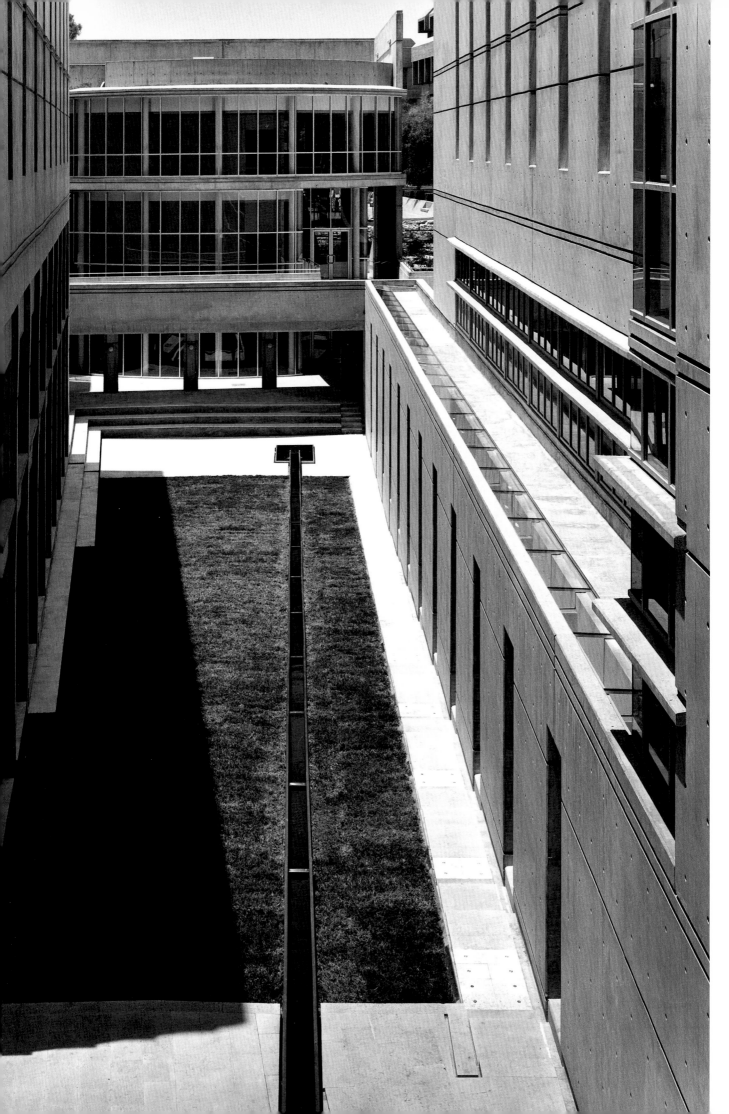

Lobby at garden level of the Henwood-Oshry Life Sciences Teaching Laboratories.

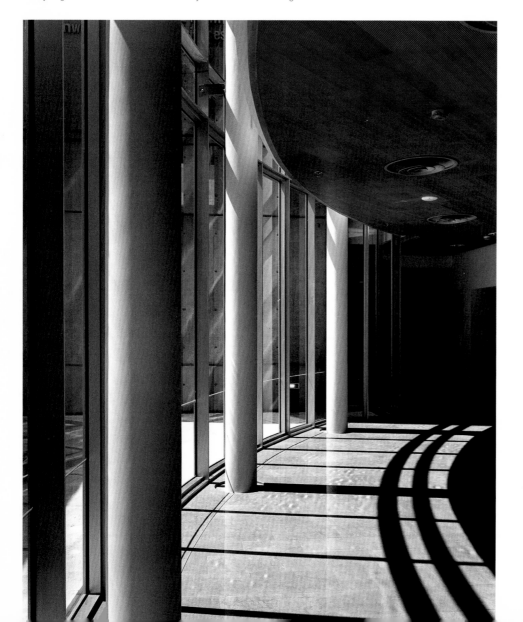

Construction drawing >

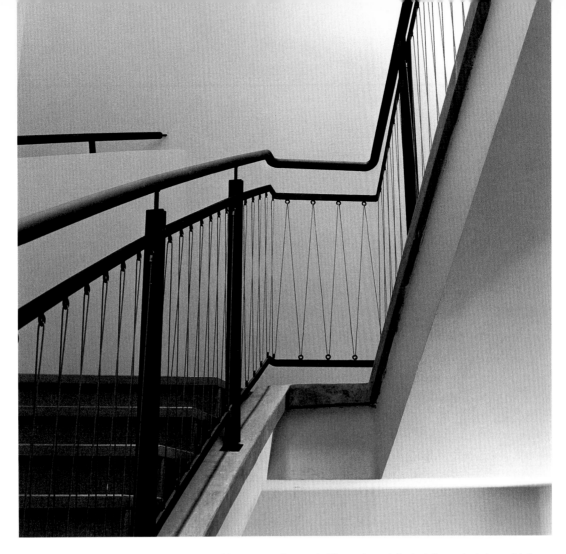

Emergency staircases double as primary daily circulation routes between lab floors.

>

< Construction drawing

Two-story lobbies in the Equipment Center allow light from the inner garden to illuminate the basement research spaces.

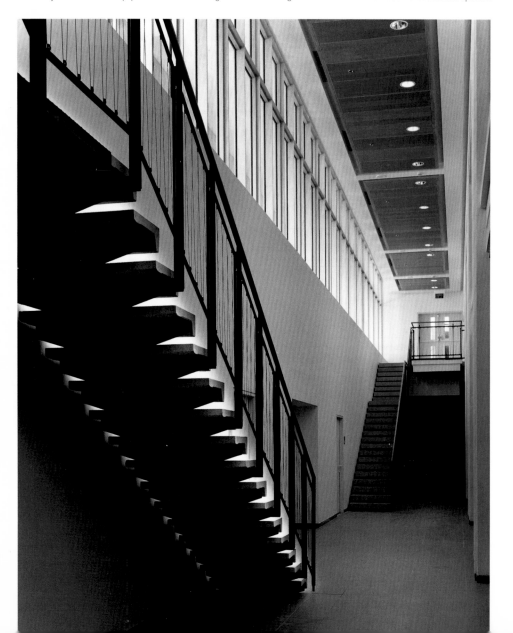

Construction drawing >

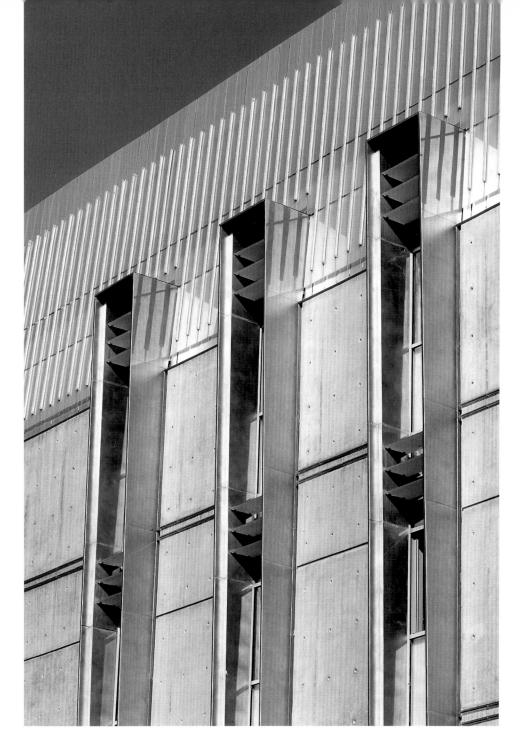

The glass panels and mullions of the roof parapet reflect in the sides of the stainless steel laboratory window "hoods".

>

< Construction drawing

View from second floor lobby of Henwood-Oshry Building eastward along central garden. >

ישראל חדשה
בנגב

NEGEV – THE NEW ISRAEL

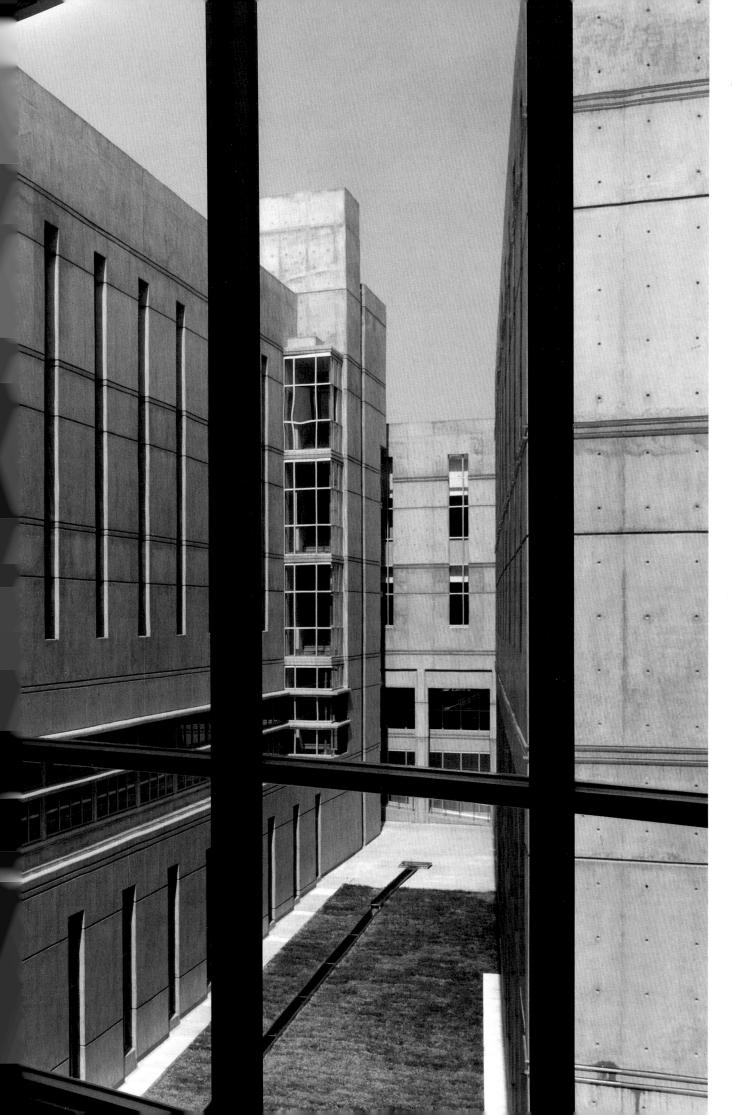

58　**FAÇADES : Casting in Place**　In order to establish a lively sense of place and character, the detailing of the cast in-situ concrete of the Life Sciences Buildings at Ben-Gurion University of the Negev explores a range of formal strategies as outlined in the introductory essay. The challenge was to control the construction process and promote the unanimity of the basic building skins. We wanted an essentially clean backdrop against which one could more clearly read localized expressions. We also wanted a common language of detailing that would establish the buildings as a family. Several primary detailing decisions control this basic unified look of the finished concrete.

The typical finished concrete wall is 22 cm thick with its finished surface cast against 110 cm wide TEGO plywood boards faced with a smooth phenolic film. In the vertical dimension, all of the floor-to-floor casts were made in two separate pours of 242 cm and 138 cm in height divided in-between with a continuous 4 cm rebate line. The formwork was backed by steel and held together with a uniform grid of tie rods spaced at 55 × 63.3 cm that marks the entire façade.

The floor slabs behind the exterior walls are described by two matching 4 cm rebate lines spaced 10 cm apart. The floor slabs cantilevered free of the walls are 24 cm thick at their forward edges and divided into two 10 cm halves by a 4 cm rebate line. The top 10 cm division here continues the 10 cm slab articulation of the main walls, thereby producing a continuous horizontal expression that wraps around the entire complex at consistent elevations. Wherever required, vertical control joints match the width and profile of these horizontal rebate lines.

All impressions in the concrete surface are cast to an even depth of 2 cm. These impressions not only include the rebate lines and control joints, but also the vertically attenuated "shadow" frames above and below slot windows, the profiled tops of parapet walls and the continuous negative panel that receives the landscape at the base of each exterior wall.

Special engineering and design efforts went into making anomalous structural conditions fit the desired uniformity of the concrete. One example was the joint between the slab and outer wall. Because both the slab's thickness and its top elevation varied, the steel reinforcing, concrete mixture and casting technique were adjusted so as to prevent additional lines, textures or color variations on the exposed faces of the façades. This necessitated the re-sizing and re-shaping of the formwork and additional consideration for the physical attributes of the concrete mixtures as they hardened at varying pressures.

Another example was the marks of the tie-holes. In certain places, the uniform tie-hole grid did not allow the contractor positions to properly support the formwork. Rather than disrupt the grid and produce disjunctive holes in the façades, the design and construction teams invented several workarounds. These included establishing ways to stabilize the formwork from the outside by augmenting its effective structural depth as well as the creation of a miniature tie-hole. This latter element was 25 percent of the standard tie-hole size and was rendered invisible by plugging it once the concrete had set.

Detail drawing >

<

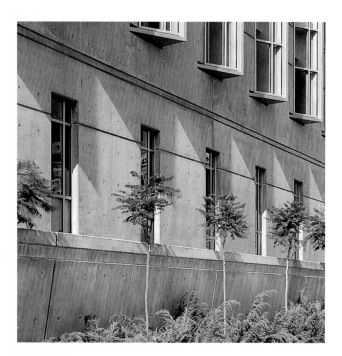

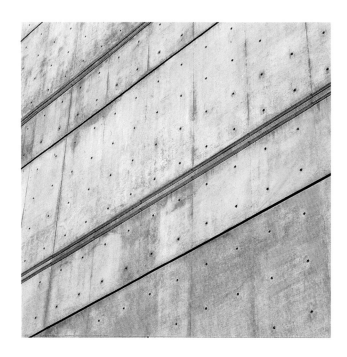

>

< Detail drawing

CONCRETE IS A DYNAMIC BUILDING MATERIAL. IT MAY SUGGEST A SOLID VOLUME AND MUSCULAR FORMS OR BE SPREAD THIN AND LIGHT LIKE PAPER. IT CAN APPEAR FOLDED, SHEARED, CURVED AND STRETCHED – OR COMPLETELY STOLID AND STATIC. ITS FINISHED SURFACE CAN BE SLICK AND SHINY LIKE POLISHED STONE OR BE CRAGGY AND ROUGH LIKE A LUNAR LANDSCAPE.

Façade articulation, de Picciotto Institute of Applied Biosciences. >

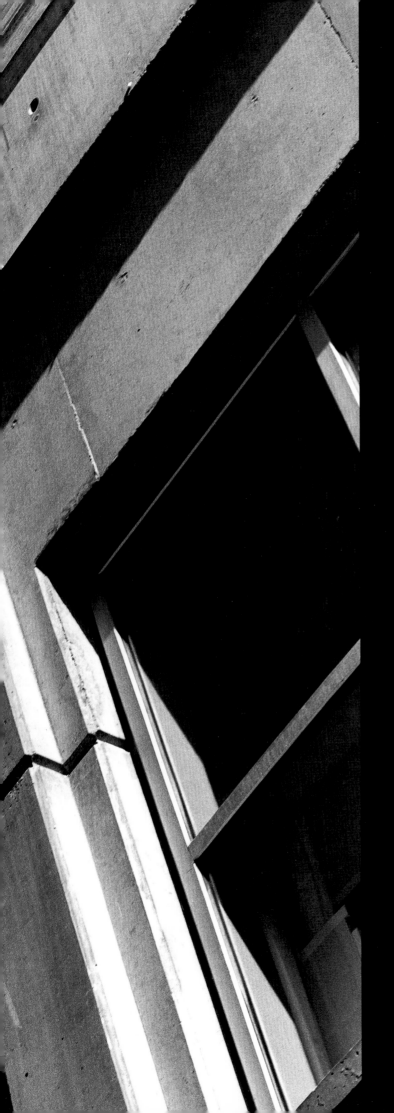

62 **FAÇADES : Wall Openings** It was pre-determined that the Life Sciences Buildings at Ben-Gurion University would rely on well-insulated walls and sophisticated air handling systems to maintain proper climatic conditions for the sensitive biological research within. The harsh glare of the southern sun coupled with the stark nature of the northern views generated the desire, however, to further protect and improve the working environments. This led to questioning the shape, geometry, orientation and materiality of all the wall openings.

In the initial sketches, concrete sunshades covered the southern window openings while concrete window boxes extended out from the north and east elevations. These early window treatments added both scale and order to the façades. At the same time, the concern arose that too much concrete would lead to a certain "material fatigue" and a heavy look.

Research revealed that a durable, yet malleable metal would be the best material to extend the palette beyond concrete. The team examined the full gamut of architectural metals from aluminum to titanium to zinc.

Stainless steel offered two special qualities that made it the eventual choice. First, stainless steel complimented the concrete and the simple interior palette of materials (glass, stone, beechwood and painted plaster). Second, stainless steel could be bent, welded, ground and polished to form seamless volumes. The metal forms would need to be taut and volumetric rather than thin and planar, the reasoning went, so that the strength and opacity of the finished concrete would not overwhelm them.

While several factories in Israel specialize in the stainless steel fabrication of industrial kitchens and manufacturing, none had ever produced architectural elements of the scale and precision required for this project. In the final design, the window hoods were several stories in height. This implied both tremendous weight and significant thermal expansion. The elements were unitized, each structured separately while still maintaining the appearance of the continuous volume. A further challenge, the expansion joints were to match the exact height and width of the rebate lines in the concrete and the horizontal window divisions.

The impact on the lab rooms and offices of expanding the depth of the window through the use of stainless steel is striking. The light that bounces off the fins and is diffused through the glass louvers softens the texture of the surrounding walls while simultaneously giving them body. The additional volumes present an added depth to the walls when perceived from within. Recalling the traditional bearing wall, this adds a sense of both protected enclosure and privacy.

Detail drawing >

<

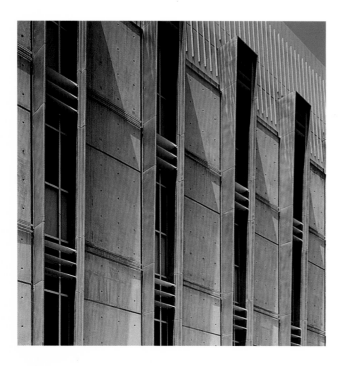

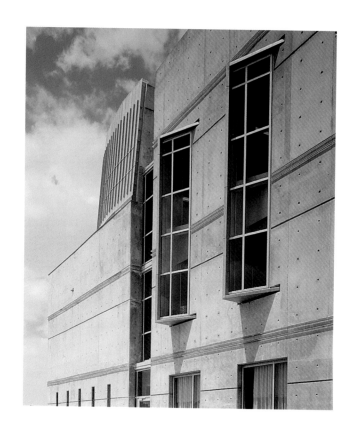

>
< Detail drawing

BEER SHEVA IS AN ISLAND IN THE LANDSCAPE. TO THE NORTHEAST, A CARPET OF RED CLAY
COVERS THE ROLLING HILLS STRETCHING TO THE CITY EDGE. A DISTANT DUSTY BROWN
TERRAIN RISES FROM BEHIND THE LAST ROOFLINE, FOLDS AND SPREADS TO THE HORIZON.

Laboratory windows on north and east façades pivot out of the concrete wall. >

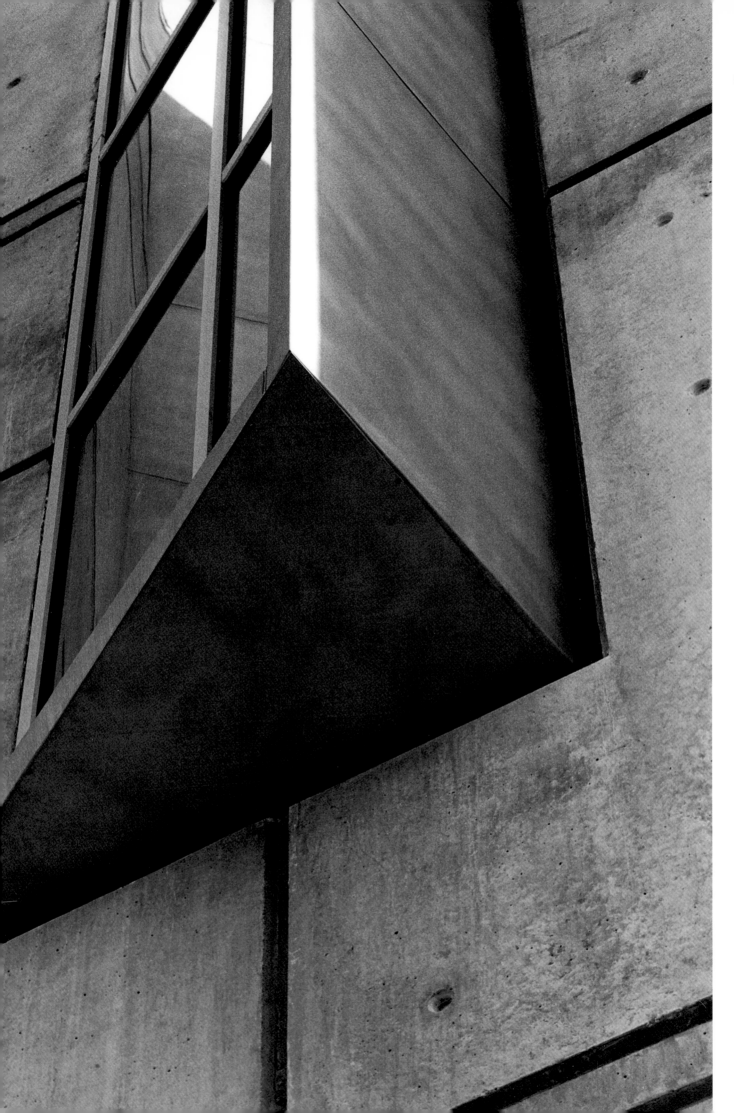

FAÇADES : Glass Roofs In the original drawings submitted for permit, the southern façade of the de Picciotto Institute of Applied Biosciences Building did not have a glass roof. Indeed, with planned parapet walls of 2.20 m in height hiding most of the machinery-laden roofscape, any additional roof structure was unnecessary. A late decision on the part of the client to include a greenhouse laboratory at the eastern end of this façade inspired new thinking.

The greenhouse required a separate roof structure with a conic profile in section to maximize the penetration of light. A singular conic roof form, however, might have fragmented the façade. The extension of the glass profile all the way across the façade to the west resolved the aesthetic dilemma and proved fortunate in other ways too.

First, the new roof form made for better proportions. The top third of the elevation contains the floating glass crown of building, while the bottom two thirds, the concrete body, sits solidly on the earth.

Second, the new roof form gives the institute a dynamic face. The translucent glass looks fresh and bright in the Negev sun and brings similar qualities to the finished concrete.

Third, in conjunction with the stainless steel hoods protecting the lab windows, the new roof form brings a material depth and dimensional complexity to the façade. The shadow reveal between the glass roof and the concrete is lined with stainless steel to suggest that the wall construction is an amalgam of concrete and pure metal. Detailing the glass as a thin skin floating free above this flashing layer further enhances this notion.

Each of the vertically proportioned glass divisions is further segmented into three parts separated by 3 cm air slots that continue the horizontal expressions of the rebate lines from the adjacent walls. The standard glass unit is 1/12th of the 330 cm building module in width and held on either side by a simple flat aluminum mullion. This mullion is articulated with T-shaped stainless steel caps on both the inner and outer surfaces. To the inside, the protruding flange is fastened to a series of pipe beams that are, in turn, held with stainless steel U-shaped trusses designed to allow the flexible use of the space of the roofs they cover. To the outside, a similar flange gleams in the low-angled sunlight of early mornings and late afternoons.

Detail drawing >

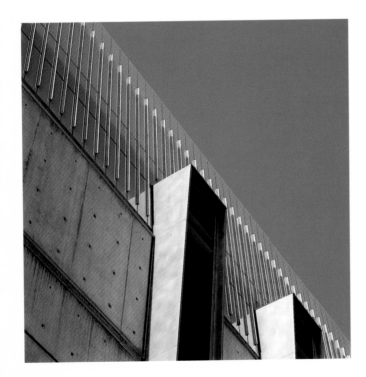

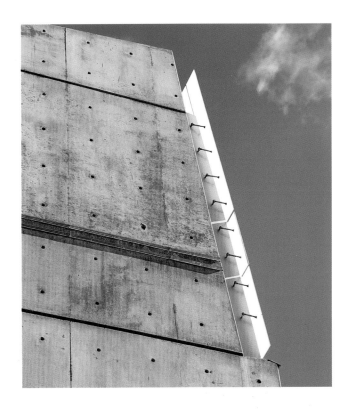

>

< Detail drawing

AT EACH CORNER OF THE BUILDING, THE FRAME-LESS EDGE OF THE GLASS SURFACE HOVERS
ABOVE THE LUMINOUS STAINLESS STEEL WITH ITS EDGE LINING UP WITH THE GEOMETRY OF THE
INTERSECTING CONCRETE WALL. MECHANICAL ARMATURES EMERGE FROM THE METAL REACHING
OUT TO PIN AND CAPTURE THE FREE ENDS OF THE FLOATING GLASS PLANE.

Modular design allows for large, open interdisciplinary laboratory spaces. >

FAÇADES : Concrete and Glass Close examination of the related, yet often opposing characteristics of concrete and glass – while beautiful in their own right – initiated several focused design investigations. The observations and conclusions that resulted left definitive marks on the project by fostering very particular detailing strategies for the façades.

Clear Strips In trying to satisfy the mechanical systems demands for the greenhouse laboratory, we discovered to what extent the transparency of glass becomes an issue of proximity. Light rays pass directly through regular clear window glass. Thus, the perception that glass has physicality arises mainly from the presence of objects on its surface such as dust, dirt, oily film and coatings. The eye can perceive foreign substances only at close distances where it finds and focuses on them, discerning their boundaries by subtle shifts in texture or tone. Therefore, the further one's distance from transparent glass, the clearer it appears. At a certain distance, it is so clear that it practically disappears altogether.

This phenomenon is put to use in the design of the inclined translucent wall of the greenhouse laboratory on the southern façade. Fastened only along the midsections of their vertical edges, the inclined glass panels float free and disconnected on their top and bottom portions. While the result gives the wall plane a lighter and more ethereal quality, the 2.5 cm air slots between the aqua-greenish plates contradicted the objective to completely seal the building envelope for climate control purposes.

The solution to this problem came in the form of clear glass strips that were inserted between the adjacent vertical panels covering the lengths of the air gaps. Custom cut and shaped to precisely match each successive gap, the clear glass is completely invisible to the naked eye from even relatively short distances. Although different in detail, both the eastern and western sides of the glass roof that covers the southern façade appear identical.

Aqua Strips In the course of investigating the addition of stainless steel elements to the concrete façades, we thought that the addition of glass strips might "freshen-up" the concrete. This led to many mock-ups with glass of different sizes, shapes, qualities and methods of attachment. One of the nicest samples was simple glass with a relatively heavy 19×40 mm section. Slightly bluish-green in hue, it gave a pleasant accent to the concrete when turned on its edge.

During one of the detail reviews on site, the glass profile being held against a concrete face was turned another 45 degrees – almost by accident. A striking phenomenon became clear immediately to all present. Not only did the bluish-green glass strip sit pleasantly against the gray wall, but it also seemed to glow as if lit from within the opaque cement. At certain angles, it even gleamed and threw spikes of aqua sunlight down the face of the concrete. With a simple prismatic profile cut along its edge, the glass took on a dimensional luminosity and depth that defied its simple form.

Detail drawing >

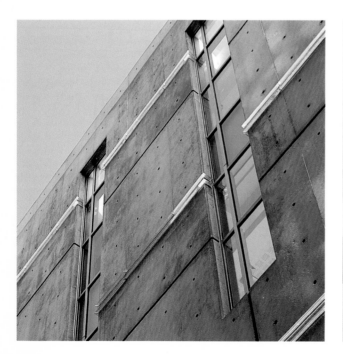

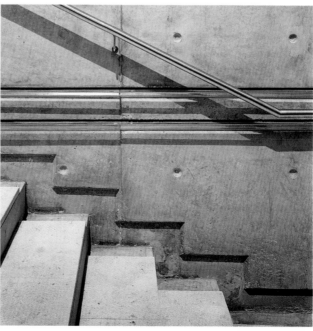

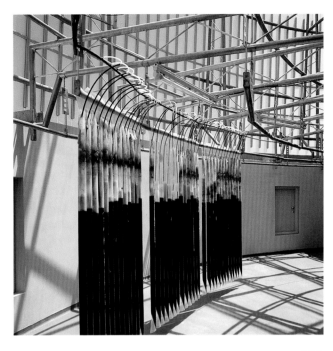

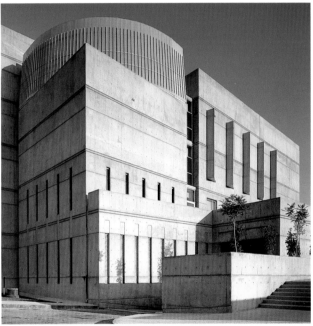

< Detail drawing

WITH SHARED CHEMISTRIES, GLASS AND CONCRETE ARE TWO KINDRED MATERIALS. EACH SERVES AS A STRONG FOIL TO THE OTHER IN A DESERT ARCHITECTURE FORMED BY THEIR INTERACTIONS WITH THE NATURAL ELEMENTS OF WATER, WIND AND SUNLIGHT.

East façade in detail, de Picciotto Institute of Applied Biosciences. >

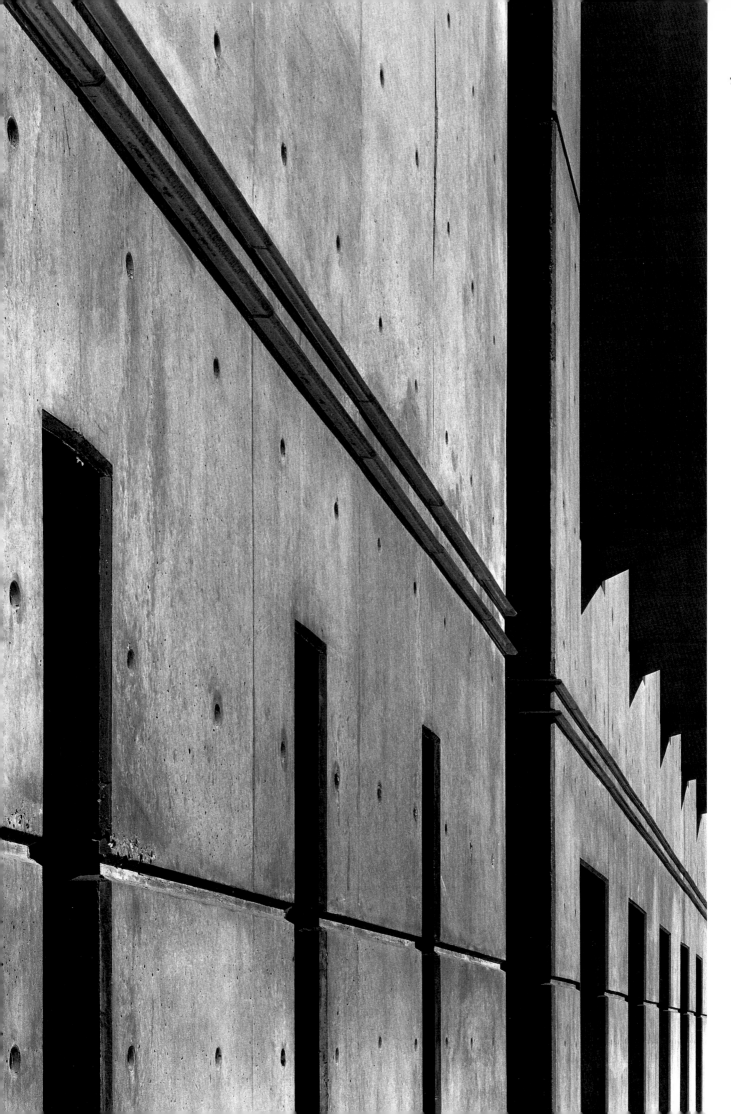

74 **MOVEMENT SEQUENCE 1 : Arrival** The engineering, forming and casting of the curved wall that forms an entryway to campus mark one of the most difficult technical feats of the Life Sciences project. Beyond the western edge of the de Picciotto Institute of Applied Biosciences, the wall gains a second side of finished concrete.

Concrete walls with two finished surfaces required much more preparation and skill. While carpenters prepared one formwork standing in place, the second was prepared on the ground nearby with the expectation that when it was lifted up and fixed together, its rebate joints, vertical panel divisions and tie-hole preparations would match up precisely. Only 22 cm apart, the space between the formwork faces did not allow room for working. Mistakes or imperfections in the boards meant that they had to be torn apart, fixed and re-erected. A gap of just a few millimeters between forms would lead to water leakage during the pour and blemished or pocked surfaces.

Making the job even more challenging, the garden face of the curve is slotted with 6 m high openings to form a giant fresh air vent for the HVAC units buried beneath the front garden off Ben-Gurion Boulevard. Each of the fifteen 25 cm wide slots that form the air vent have their own unique opening size to the air plenum behind and thus their own unique shape. Custom sizing was necessary because the landscaping on the opposite side of the wall above the roof of the plenum ascends around the curve at the pitch of the main entry stair.

The elaborate scheme allowed for full maximization of potential air intake without disrupting the visual continuity and rhythm of the internal façade of the wall for the garden visitor. The brushed aluminum fresh air intake slot grills are set into the concrete in a rhythmic manner. The actual air intake openings in the concrete remain invisible behind them.

The wall continues its tectonic gymnastics when passing both the last air intake slot and the last flight of the main stair. Within less than a meter, the wall transitions to a straight geometry and becomes an upstand parapet beam that holds a 13 m long bridge over the central garden. The reinforcing steel at the point of maximum shear in this location is so dense that the contractors feared there would not be room for the finished concrete to spread evenly. Having spent nearly six weeks on preparing the forms for this special wall, however, they took great care during the pour.

Detail drawing >

<

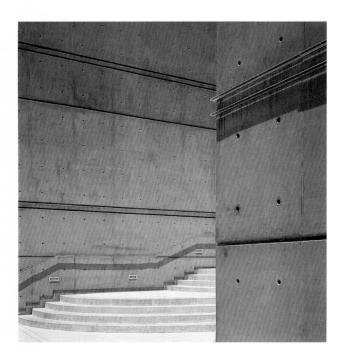

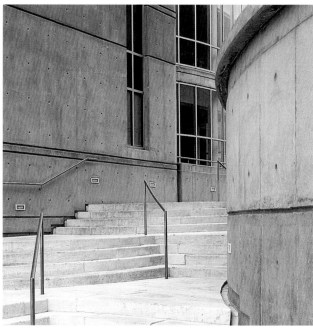

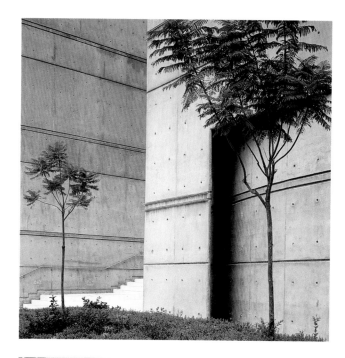

>

< Detail drawing

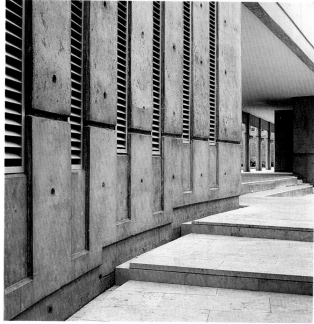

OPPOSITE THE SOUTHEASTERN ENTRANCE TO CAMPUS, THE BASE OF THE DE PICCIOTTO
BUILDING PEELS BACK IN A GENTLE CURVE. THE WALL SLIPS UNDER A COLUMNAR LEG THAT
MARKS THE BUILDING CORNER. TWISTING PAST 90 DEGREES, IT REACHES THE CENTRAL
GARDEN AND LEAPS OVER IT IN A SINGLE BOUND.

View from beneath bridge as it crosses the central garden. >

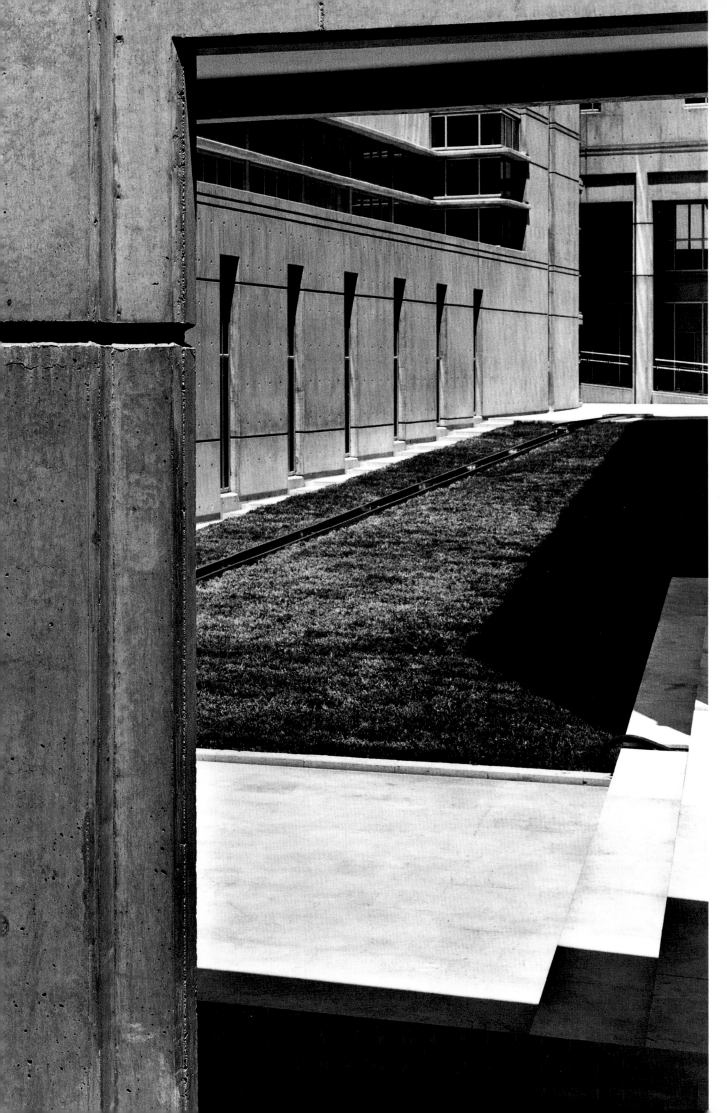

78 **MOVEMENT SEQUENCE 1 : Promenade** The public circulation route of The Toman Family Department of Life Sciences Building is pulled outside the building and borders the edge of the inner garden. A single, freestanding screen wall running the entire length of the garden and under the bridge defines the special passage.

This wall acts as a sieve for both natural light and the green outside. The upper and lower mullions of the skylight enclosure between the building and the detached wall are hidden from view. This detail promotes both the ambiguity between inside and outside and the soft, solitary character of the wall. Strong southern light enters through the skylight, bouncing off the opposing edge beam and flowing gently down the smooth plaster surface to the stone floor below.

A series of vertical slot windows gives rhythm to the corridor and allows episodic views of both the greenery and the strong façade of the de Picciotto Building across the garden. Falling along the floor and up the opposite walls, sunbeams penetrating through these slots shift during the day in a play of light and shadow.

The passage is not only the primary ground level connection between the graduate labs, the administration area and the undergraduate teaching lab building, but it also doubles as the Life Sciences Department's gallery of scientific exploration. The inner wall of the corridor is lined with large display cases that demonstrate the department's work through posters, press-clippings and small samples. The gallery cases are situated within floor-to-ceiling window walls beyond which are the offices of the researchers. The corridor drops 90 cm from its start along a ramp to maintain the researchers' privacy through the shift in section. At the same time, the apertures in the outer wall are designed so that the researchers have an uninterrupted view into the inner garden while seated at their desks.

Detail drawing >

<

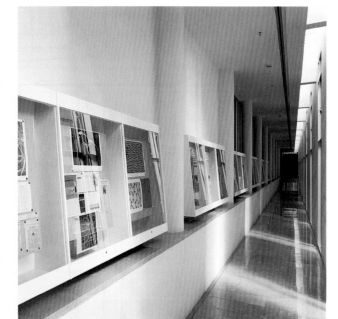

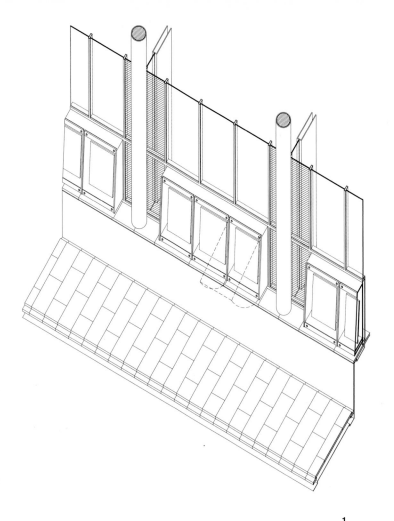

Movement Sequence 1

1

(1) axonometric sketch
(2) section detail: corridor gallery display cabinet
(3) partial interior elevation: modular cabinet inset in glass office partition
(4) partial plan: corridor gallery on southern side of modular research offices

(A) Interior glass partition wall.
(B) Enamel-painted wood cabinet.
(C) Hinged glass cabinet door.
(D) Demountable "floating" display panel.
(E) Sheetrock insert.
(F) 4 cm stone-lined shelf.
(G) Plaster.
(H) 4 cm stone flooring.
(I) Stone channel. Plaster wall is detached from main floor surface by 7 cm wide stone-lined channel.
(J) Milky glass. Helps to keep offices private.
(K) Clear glass. Separates between space of office and corridor.
(L) Display cabinet.

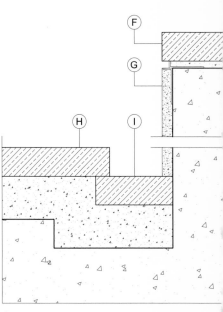

2

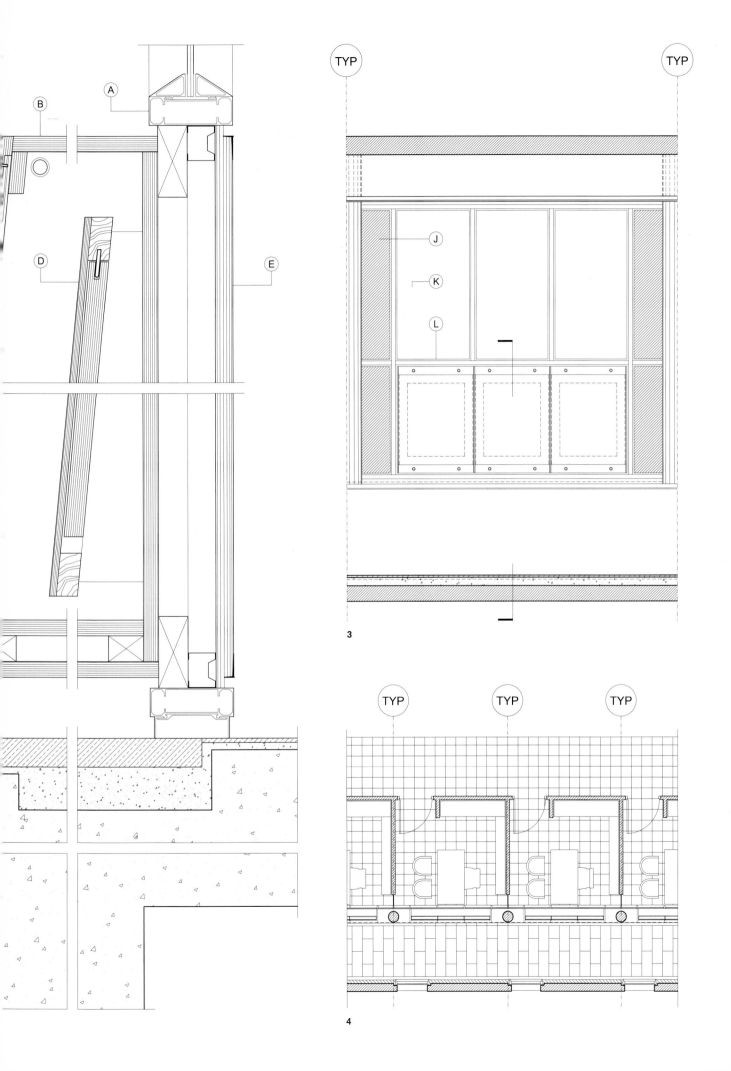

A

B

D

E

TYP

TYP

J

K

L

3

TYP

TYP

TYP

4

< Detail drawing

LANDING ON THE CAMPUS PROPER, THE BRIDGE PARAPET FOLDS INTO ANOTHER WALL THAT BORDERS THE CENTRAL GARDEN ALONG ITS NORTHERN SIDE. FROM THE BRIDGE, THE CONTINUOUS TOP EDGE PULLS THE EYE ALONG AND INTO THE DEEP, CONVERGING PERSPECTIVE LEADING PEDESTRIANS AWAY FROM THE CIRCULATION PATH AND OVER TO THE PARAPET. THE GARDEN IS SPREADING OUT AS IT DISAPPEARS BELOW THEIR FEET.

Deep shadows accentuate the rhythm of the southern façade of the Toman Family Building. >

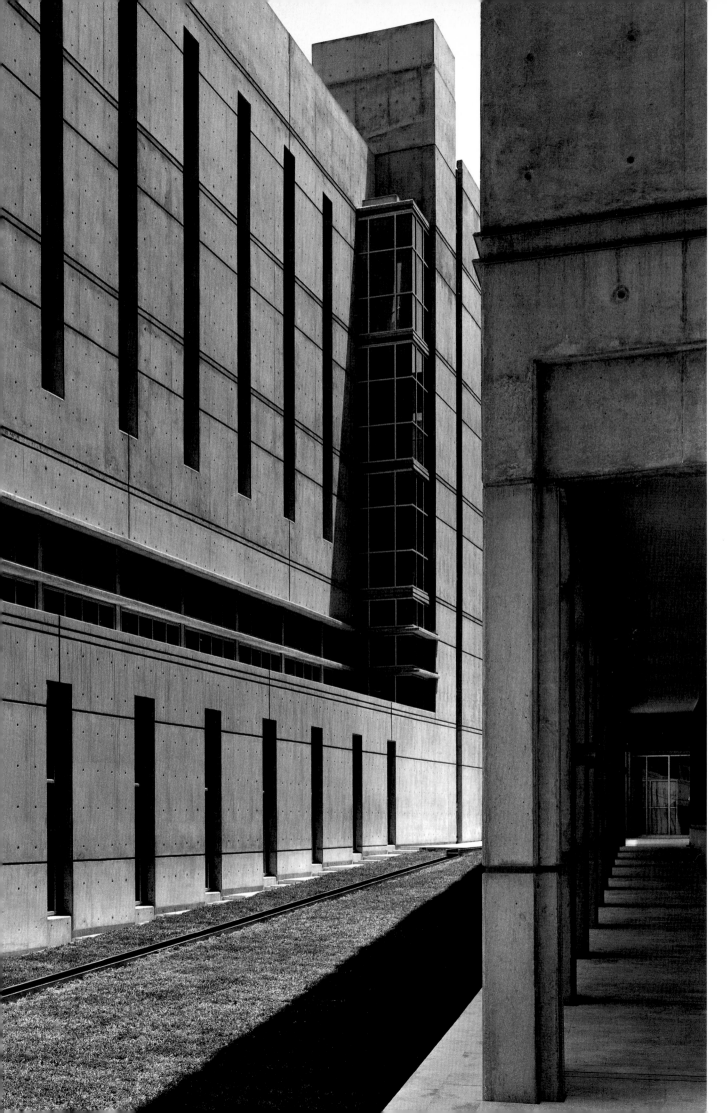

MOVEMENT SEQUENCE 1 : Ascent The eastern end of the corridor gallery of the Toman Family Department of Life Sciences Building continues on in a singular gesture to become the main stair. At the second landing, the stair turns and then climbs skyward, passing in and out of the corner of the building. The spiraling upward movement links all the lab floors through extended elevator lobbies with small lounge spaces at alternate floors for coffee breaks and informal discussions.

The outrigger stair design presents different vantage points at either end. The landings to the west have dramatic views of the narrow interior garden below. These landing platforms seem to float in space cantilevered out beyond the building envelope and detailed from floor to ceiling in glass. In contrast, the east landings approach the façade of the de Picciotto Institute of Applied Biosciences Building to a distance of just 2 m where an unexpected intimacy occurs between the buildings' occupants.

The finished edges of the concrete landings expose the depth of the structural slabs. They are designed to match the major divisions of the walls that contained them. This is achieved by running the primary floor rebate joint across the slab and splitting the slab face into two smaller dimensions of more pleasing proportions.

The formal clarity and vertical expression of the stair tower are preserved the entire way to the top by completely separating the east and west walls. The resolution of that design strategy in detail suggested a mullion-less glass connection at the roof where the slot window that separates the two halves of the stair tower wall folds effortlessly to become a horizontal skylight. The vertical glass wall appears to dissolve into the sky.

Detail drawing >

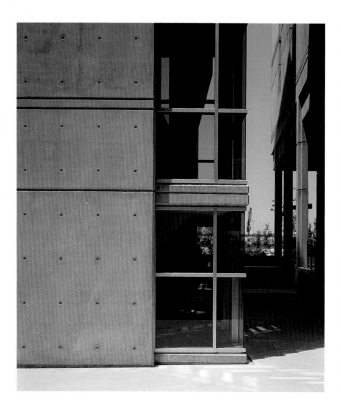
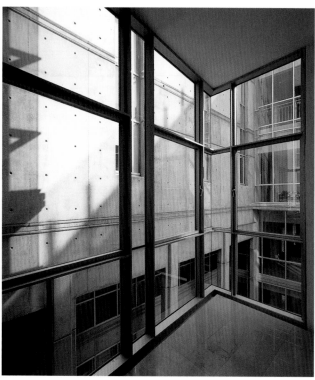

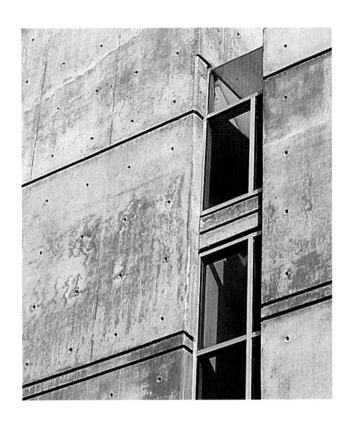

< Detail drawing

THE LONG, SMOOTH CONCRETE WALL MAKES A GENTLE ASCENT TOWARD THE UPPER
COURTYARD. HERE IT SPLITS AND SHOOTS SKYWARD FOR SIX STORIES WHERE IT FOLDS
TO FORM THE CROWN OF THE STAIR TOWER VOLUME.

Light reflections on south façade of Toman Family Building. >

MOVEMENT SEQUENCE 2 : Ingress Dynamic spaces are those that present one face when seen from one direction, and a completely different one when seen from the other. Such is the case with the main lobby of the Institute of Applied Biosciences that has the dual functions of providing a comfortable and elegant living room for the institute as a whole and simultaneously being its space of collection and distribution.

The lobby is organized around a large freestanding object that commands the lobby volume. It is a large curved cantilevered wall that rises from the basement up into the double-height space of the lobby. Concave in shape and clad in the warm tones of beechwood, the large wall draws immediate attention upon entering the building. It forms a structure and backdrop to a long bench that encourages informal and impromptu gatherings. The bench and the wall behind it suggest repose and comfort while giving the entry space a dignified character.

The two main processional stairs of the building are cantilevered off the curving wall. One stair leads down to the lobby of the Equipment Center, a vast complex of specialized labs shared by researchers from all over campus. The other stair leads up to the administration wing of the IoAB that houses a large meeting room for guest speakers and seminars on the biosciences.

The gentle slope and sweep of these stairs provide an easy promenade between levels and a gradual introduction to the spatial sequence of the building. Ascending, the view focuses back toward the entry that is now understood to be the intersection between the building's main axes. From here, four primary functions are accessible: 1. a garden terrace to the east of the building; 2. an administration corridor looking to the inner garden; 3. a bridge leading over a four-story tall atrium to the west lab wing of the institute; and 4. a stairway leading up to the east lab wing.

Traveled in reverse, all the major paths within the building lead back down to the lobby, the heart of the institute.

Detail drawing >

<

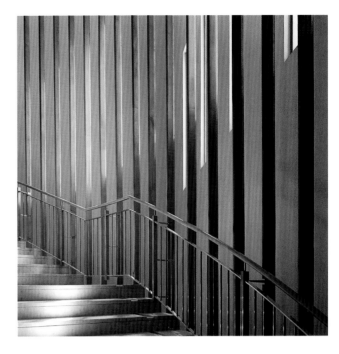

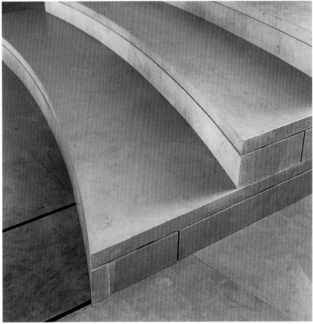

THE NORTHERN FACE OF THE DE PICCIOTTO BUILDING TURNS SOUTH TO THE NARROW ENTRY PASSAGE AND STEPS DOWN ALONG THE SEAM BETWEEN THE STAIRWAY AND RAMP WITH TALL, SLENDER COLUMNS. THE ARCADE WALL FORMS THE EDGE OF THE UPPER COURTYARD AND PASSES STRAIGHT INTO THE BUILDING THROUGH THE FOUR-STORY HIGH CURTAIN WALL. CONTINUING PAST THE ELEVATORS, THE WALL BECOMES A SINGLE GIANT COLUMN PIERCING THE SOUTHERN SIDE OF THE BUILDING AND OPENING VIEWS TO THE NEGEV DESERT.

Spiral stone stair as it emerges from the basement level lobby. >

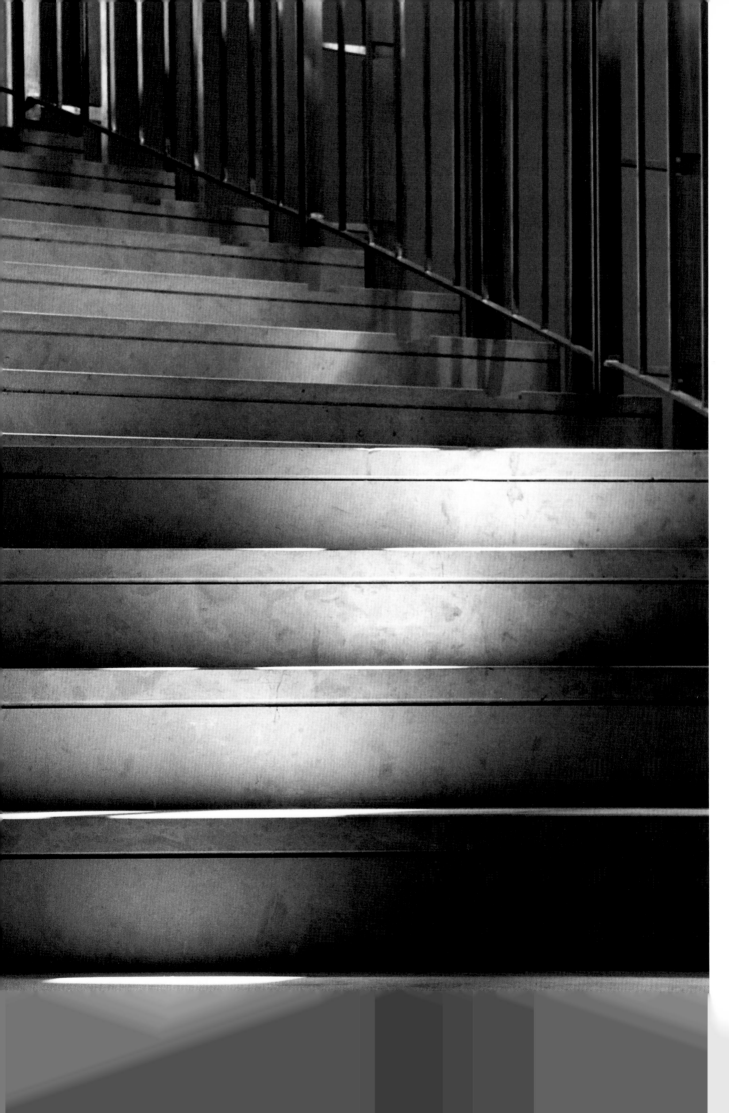

MOVEMENT SEQUENCE 2 : Deliberation If the lobby of the institute is the "conceptual heart" of the building, the meeting room is the "conceptual head". It is the place of dissemination, discussion and decision.

Organized concentrically, the conference tables permit both large or small groups ease of communication. The meeting room maintains a main axis, however, to allow attentive focus on the westside of the room where both a demountable speaker's podium and a retractable multi-media screen rest.

More significantly, the meeting room axis continues the axis of the main garden. With the media screen withdrawn and the curtains parted, a large window reveals the complete view across the entire length of the central garden. The view signifies the ever-present link between the mission of the Institute of Applied Biosciences and the natural world.

In trying to maintain a warm atmosphere in the public spaces of the Life Sciences Buildings, one of the greatest challenges was the design of their ceilings. In lab buildings as dense as these, a large proportion of the building services cross these public spaces above the corridor spaces aligned with or adjacent to their edges. This not only lowered the finished ceiling heights in these corridors, but the pipes, dampers, cable trays and sprinkler systems above these ceilings all required 100 percent accessibility.

The design strategy was to avoid the technocratic look of standard lab buildings where the common solution for accessible ceilings is a 60 × 60 cm drop-in tile-ceiling grid. In conjunction with the acoustical contractors and carpenters, demountable wood ceilings were designed for the corridors from the same elegant fixed acoustical wood panel system with a beechwood finish that covered ceilings of the main spaces. The special challenge here was the unification of multiple ceiling shapes and dimensions. Executed with exacting care and precision, the difference between the fixed system and the demountable system is negligible.

Detail drawing >

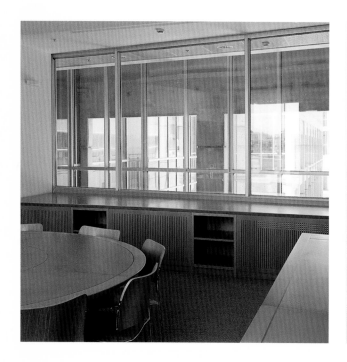
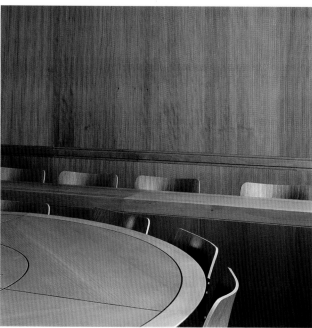

< Detail drawing

TURNING LEFT AT THE TOP OF THE STAIRS, THE GAZE SHOOTS WESTWARD DOWN THE 60 M LENGTH OF THE
CENTRAL CORRIDOR, PAST THE AIRY BRIDGES, PAST THE DOUBLE DOORS. THE PERSPECTIVE DIPS INTO THE
SUBDUED REALM OF THE LAB CORRIDOR BEFORE EMERGING IN A PINPOINT OF WINDOW LIGHT AT THE FAR
END. A SINGLE GAZE – AND THE INSTITUTE'S ENORMITY IS UNDERSTOOD.

Central public stair of de Picciotto Building climbing to a landing overlooking the city. >

MOVEMENT SEQUENCE 2 : Passage Shaped like a giant "L", the large floor plate of the de Picciotto Institute of Applied Biosciences Building splits into two distinct entities bent at right angles to one another to enclose the central garden. Extruded upward, these two entities form separate building volumes containing a majority of the laboratory and office spaces. The elbow joint between them houses specialized functions at each floor, including the lobby, special laser research labs and a greenhouse. It also houses the building's central service core that provides utilities to both building wings. The utilities emerge from and return to these wings from the ends of the core to which they are adjacent. This leaves a blank core wall facing the inner garden.

The IoAB is configured thus to leave an elastic zone at its center belonging neither just to the institute nor just to the central garden. This zone contains the actual threshold between inside and outside in the form of a large clear glass curtain wall that seals the building envelope. More importantly, however, the zone holds three bridges that pass between the diaphanous curtain wall and the mass of the core, conceptually sharing the extended space of the upper courtyard.

The bridge offers a passage and a view over the space of the upper courtyard and an experience of its placid sun-filled atmosphere. Therefore, the relative transparency of the curtain wall allows the private realm of the IoAB to blend into the communal realm of the larger complex, a design strategy further enhanced by the articulation of the curtain as a freestanding, independent skin.

Starting at the northeast corner near the entry, the curtain stretches down along the side of the courtyard to the end of the core structured by finger-like reinforced concrete brackets cantilevered out horizontally from the massive core wall. The giant, north-facing glass wall reaches from the finished stone floor up to the top of the roof parapet 17.50 m above, ending as a frameless glass cornice against the sky and held at a distance from the roof by an invisible clear glass skylight.

Working in conjunction with the window systems engineers, we fashioned custom connections between the freestanding curtain wall and the structural concrete cantilevers. These connections emerge from the plaster at a 2 cm width that matches the thin extension of the vertical mullion profiles. Clad in the same white anodized aluminum of the curtain wall and adjustable in three directions, the new narrow attachments appear as elements from the design family of the original window system.

Detail drawing >

<

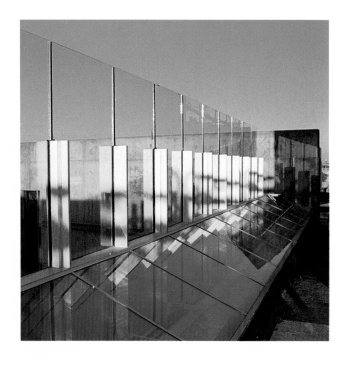

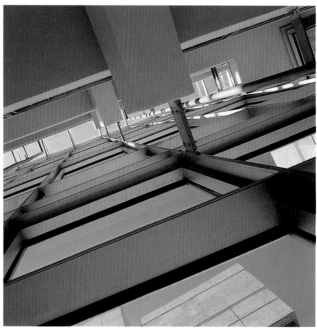

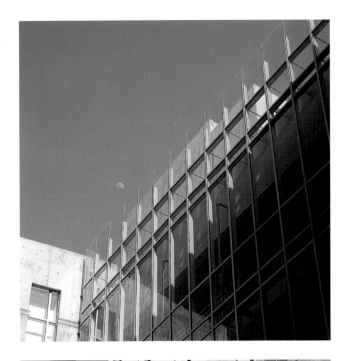

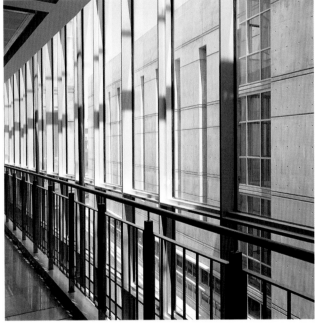

< Detail drawing

THE SUNRAYS BREAK OVER THE TOP OF THE PARAPET WALL OF THE CENTRAL GARDEN COLLIDING AGAINST THE CONCRETE OF THE OPPOSITE FAÇADE. SPENDING PART OF THEIR ENERGY IN A RADIANT GLOW, THEY FALL ACROSS THE GARDEN AND THROUGH THE GLASS THAT SLOWS AND DIFFUSES THEIR INTENSITY. STRIKING THE WALL BEYOND THE BRIDGES, THEY GLEAM, SHIMMER AND DROP SOFTLY TO THE FLOOR.

Soft light illuminates the connections between the bridge supports and the wall of the building core. >

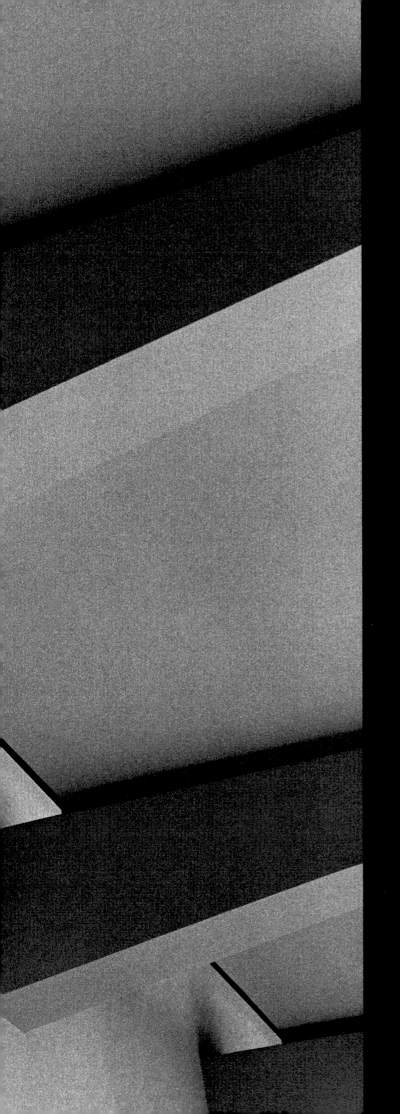

GARDENS : Spine The body of the inner garden is bordered on three sides by the walls of the two graduate research buildings. The introspective nature of inner gardens is designed as a balance to the intensive pursuit of scientific knowledge going on behind these walls.

The palette of landscape materials remains strict and spare to permit serene, contemplative strolls along the garden arcades. Horizontal surfaces for walking are covered with the same warm whitish Hebron stone lightly hammered to break the hard Beer Sheva light and prevent slipping. Clear, greenish glass strips set between the stones provide accents along defining edges. A green carpet of grass is stretched taut between the upper and lower courtyards, while a single almond tree marks the end of the garden just off the arcade path.

The concrete of the garden was designed well in advance to accept the final stone detailing. Its casting required particular care and delicacy. The landscape design called for exacting precision to accommodate final drainage invert levels as well as crisp, sharp corners to match the stone edges.

The length of the garden is articulated with a narrow channel of water. Bubbling up in a small pool, the water flows in a stainless steel flume, streaming down the garden slope in a series of cascading falls that generate a soothing sound. With one final splash, the water pours from the flume into a small reflecting pool near the foot of the small amphitheater.

At night, hidden fiber-optic cables illuminate the length of the flume from beneath the surface of the water. In the still and darkness of the desert evenings, the water appears to glow with a golden hue as it tumbles down the garden slope.

Detail drawing >

<

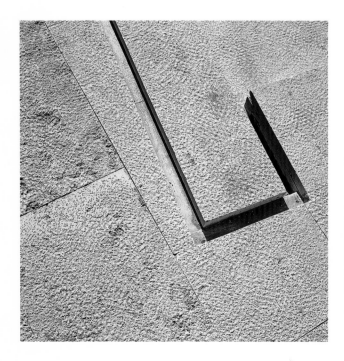

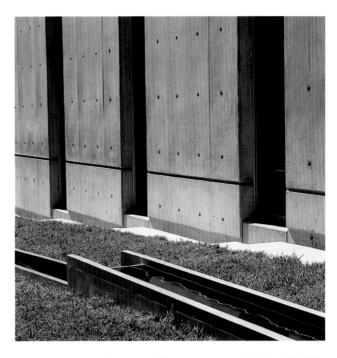

< Detail drawing

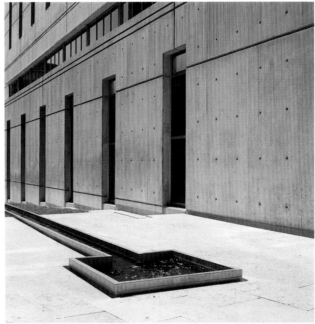

A SLIGHT GUST OF AIR WAFTS EASTWARD ACROSS THE GRASS AND FLOWERBEDS ON THE SOUTHERN LAWN OF CAMPUS CAUSING LEAVES AND PETALS TO FLUTTER GENTLY IN ITS WAKE. REACHING THE WESTERN ARCADE, THE WIND SLIDES THROUGH THE FRAMES AND UP OVER THE BRIDGE COLLECTING AGAIN AT THE FOOT OF THE GARDEN. FLOWING EVER FASTER, THE AIR PUSHES AGAINST THE WALLS AND THE LAND LEANING INWARD TO NARROW ITS PATH AS IT WHISKS UPWARD ALONG THE INNER GARDEN SLOPE. A STEADY BREEZE NOW, IT COLLECTS IN A SMALL EDDY AT THE UPPER COURTYARD AND STREAMS OUT THE CAVERNOUS GAP TO THE NORTH.

Arcade in detail, central garden. >

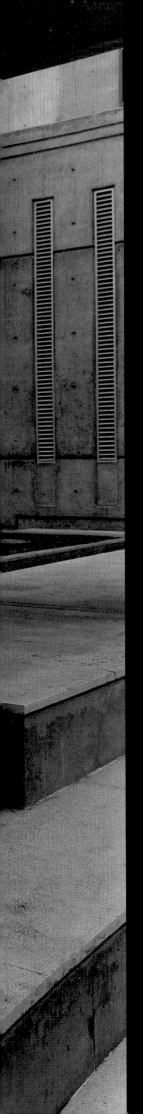

GARDENS : Sieve From top to bottom, the central garden floor slopes at a faster rate than the arcade along its side. As the arcade path swings around to enclose the end of the garden, this difference in levels is expressed in a three-stepped amphitheater that surrounds the lower courtyard. Facing the central axis of the garden and shaded from the sun by the bridge passing overhead, the amphitheater steps provide a suitable location to hold an outdoor seminar. It is also a natural spot on the journey around the campus gardens to stop and sit in restful meditation. Stones are warm to the touch and the surrounding air is refreshed with the slight evaporation of water.

The arcade that ends abruptly at the western edge of the de Picciotto Institute of Applied Biosciences Building picks up again on the opposite side of the bridge to campus facing the Henwood-Oshry Life Sciences Teaching Laboratories Building. Heading north now, the arcade forms the spatial filter through which the central garden bleeds out around the northern side of the HOTL and into the sunken botanical garden to the west. A little further on, the depth of the arcade forms a sunscreen to protect the windows of the administration of the Toman Family Department of Life Sciences Building set into the back wall of the arcade. Strong, rhythmic shadows from the broad arcade frames cross the stone path and climb diagonally up the concrete wall pointing northward to a stairwell that leads back up to the main level of campus.

Detail drawing >

<

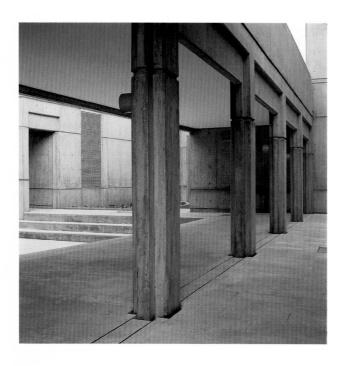

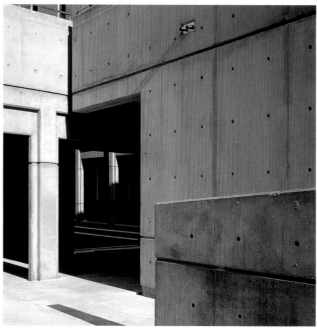

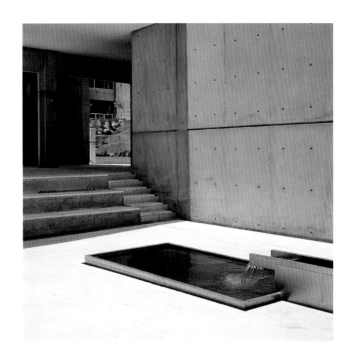

< Detail drawing

BENEATH THE CAMPUS BRIDGE IN THE MIDDLE OF THE DAY, THE ATMOSPHERE IS SOFT
AND SERENE. SUNLIGHT IS REFLECTED BY THE NEARBY STONES AND UP ONTO THE SMOOTH
BRIDGE UNDERBELLY PLASTERED IN WHITE. NEUTRAL GRAYS REPLACE HARD SHADOWS
WHILE THE SURROUNDING CONCRETE RESTS.

Main entrance lobby and student lounge, Henwood-Oshry Building. >

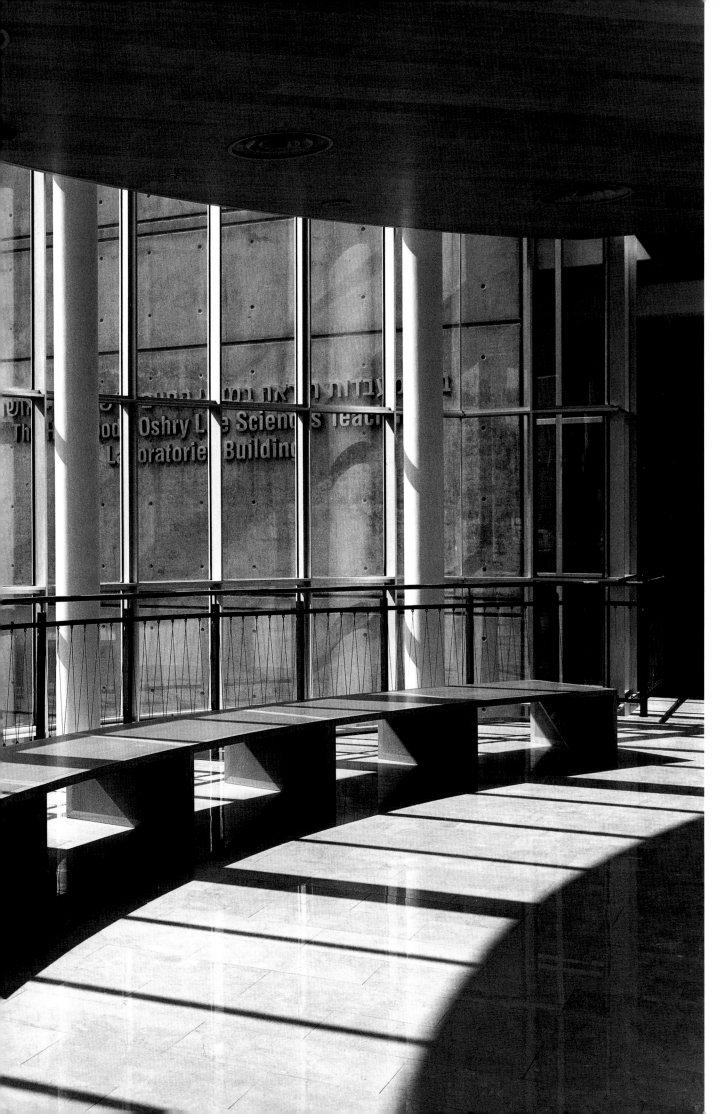

MOVEMENT SEQUENCE 3 : Extension Diagrammatically speaking, the Henwood-Oshry Life Sciences Teaching Laboratories Building is a solid, opaque box bounded on its north- and eastsides by a light skin. The solid box houses all of the sensitive, scientific areas of the building that include laboratories, technical rooms, computer areas and storage facilities while the light skin encloses the more amorphous lobby and student lounge areas. The solid box is rigid and ordered, its design conforming to the rules that govern the special functions that occur within it. In contrast, the more amorphous spaces behind the light skin create a unique spatial order based on the relationships to both the gardens and the cycle of life within the building.

The east-facing foyers of the HOTL accept the thrust of the central garden as it flows under the main bridge to campus and through the concave curve of the glass curtain wall along its central axis. The higher one goes in the building, the more commanding the view of the long central garden. From these vantage points, the depth of the converging perspective emphasizes the unity between all three buildings by establishing a strong subject-object relationship. At the same time, the detached northern wall of the HOTL initiates the two primary routes of circulation that tie the building back to the sunken botanical garden.

The first of these routes is the scissors ramp rising from the sunken garden up to the main level of campus. Climbing slowly out to the west over the botanical garden, the middle landing is extended to form a viewing platform at the garden's geometric center. From here, the ramp turns back to the inside of the detached northern façade where it rises continuously to meet the main campus level directly outside the main entry. Aligned with the ramp landings, vertical slots in the detached wall set up privileged views of the garden.

The second of these routes is the main stair connecting the garden level to the two upper floors that house the primary teaching labs and their support rooms. Two huge, object-like stair flights occupy the void created between the detached northern façade and the solid mass of the building. Both stairs climb out to the west before returning on galleries to the east on the floors they serve. Functionally, this reduces congestion by lengthening the circulation space. Spatially, this weaves the HOTL into the life of the botanical garden by promoting a view to the garden through the curtain wall that wraps the stair-gallery route on three sides.

Detail drawing >

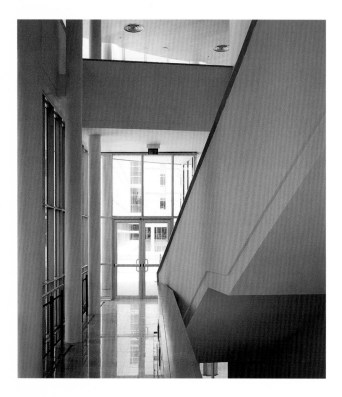

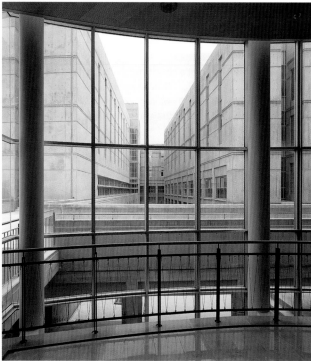

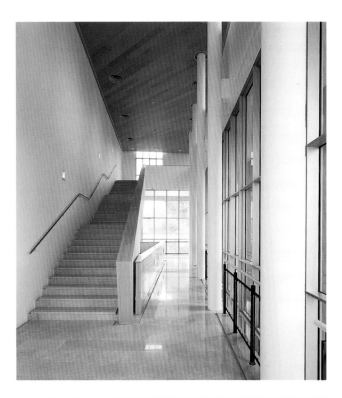

< Detail drawing

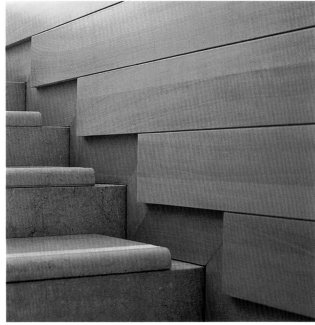

THE DETACHED NORTHERN WALL OF THE HENWOOD-OSHRY BUILDING ALIGNS WITH THE LONG
INNER FAÇADE WALL OF THE TOMAN FAMILY BUILDING. FORMING A SINGLE 90 M LONG LINE
RUNNING ACROSS THE SITE PLAN, THE ALIGNMENT OF THESE TWO WALLS LEADS THE VISUAL
EXTENSION OF THE INNER GARDEN WESTWARD PAST THE NORTH-SOUTH CAMPUS AXIS WHERE
IT LANDS IN THE SUNKEN BOTANICAL GARDEN SHARED BY BOTH AND THE UNIVERSITY AT LARGE.

Curved glass curtain wall, Henwood-Oshry Building. >

MOVEMENT SEQUENCE 3 : Orientation The design concept of the lecture hall on the garden level of the Henwood-Oshry Life Sciences Teaching Laboratories mimics that of the overall building where flowing circulation spaces surround a functional inner core. In the case of the lecture hall, the circulation space is an L-shaped ambulatory serving a slopped house and stage for 180 people. The route of the ambulatory extends the spiraling procession of the main staircases as they descend from the lab floors. After entering the hall through a low vestibule serving as a sound lock, the ambulatory wraps up and around the object-like house whose main feature is a series of overlapping shells that focus the attention back down onto the space of the stage.

Despite the direct allusions to the building parti, the windowless lecture hall takes a shape and character of its own. With a strategy that underscores the basic themes of the larger project, the house and ambulatory are formed with separate yet appropriate tectonic languages.

The ambulatory is tailored with well-crafted carpentry bringing pace, tactility and dimension to this pedestrian zone. A series of wood crossing beams divide the linear route into smaller modules. A wood pilaster extending down the outer wall from the beams and the framing lattice-like wood panels further subdivides each module. The surface of the wood panels is vertically striated, a technique that gives it an elegant texture and masks acoustical perforations on its back. The ceiling is composed of wood-framed demountable acoustical panels with a similar articulation.

The base of the wall is trimmed out with a continuous cascading panel that matches the rise and run of the stairway. Clad in full wood trim, the stairs' leading edges emerge from this panel at each bend. Every other stair extends out into the house to form the central risers.

Detail drawing >

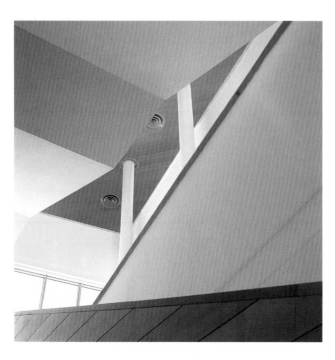

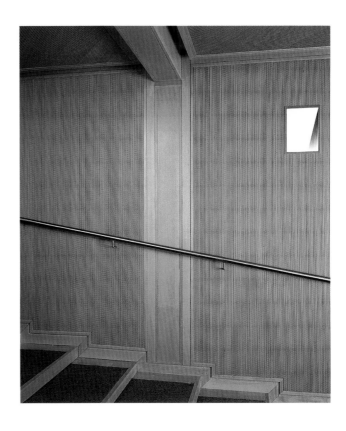

< Detail drawing

WITH THEIR FOUR PRIMARY UNDERGRADUATE TEACHING LABS AND ADJACENT SUPPORT ROOMS
THE BUSTLING UPPER FLOORS OF THE HOTL BELONG MORE TO THE CAMPUS WHILE THE TRANQUIL
GROUND FLOOR BELONGS TO THE STOIC INNER GARDEN. REMAINING QUIET AND PEACEFUL
THROUGH MOST OF THE DAY, THE SERENE ATMOSPHERE OF THE LOWER LEVEL IS DISTURBED
ONLY BY THE MID-MORNING PLAY OF SHADOWS AND LIGHT RAYS ON ITS STONE FLOORS AND THE
OCCASIONAL HUSHED DIN OF STUDENTS MAKING THEIR WAY TO LECTURE.

Public stair of Henwood-Oshry Building descending to garden level lobby. >

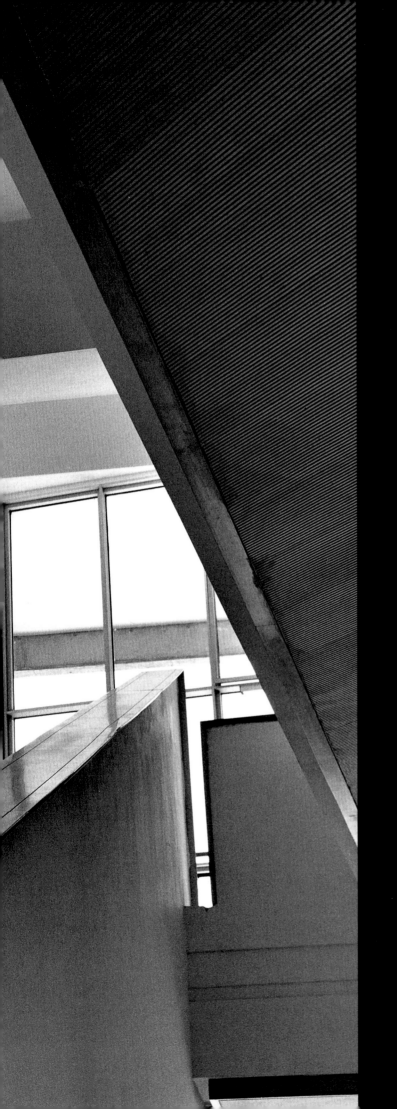

MOVEMENT SEQUENCE 3 : Study A counterpoint to the warm, staid atmosphere of the wood-clad ambulatory, the architecture of the lecture hall house and stage is lively and dynamic. The contrast not only draws the students into the central space, it elevates the mood of the room by conveying a light and spontaneous atmosphere. Based on the geometry of a slightly tilted central axis, the asymmetries of the house shells and stage provide an eccentric and animated space for science education.

Lining the inside face of the ambulatory, a thin arcade plane with leaning trapezoidal apertures forms playful gateways to the main house. Detached from this framing arcade by a 10 cm wide shadow reveal, a series of giant wing-like planes swoop in concentric arcs across the main ceiling and down the opposite wall. The flowing surfaces all angle inward toward the stage, a gently curving wood-clad plinth that is itself enveloped by the last of these detached "shells" set now in the opposite direction.

In keeping with the architectural attitude toward the whole project, technical elements are suppressed in the public spaces in order to promote a lighter, more familial atmosphere.

From hidden reveals, light softly washes the white walls and ceiling surfaces covered in a seamless fabric woven into a texture recalling canvas. The indirect and uniform illumination is set to levels appropriate for long periods of note taking and study. The ceiling profile is precisely designed around the depth of the fixtures such that no direct light or fixture is seen from either the house or the stage. Yet the lights remain easily accessible for maintenance.

Air is supplied to the lecture hall through diffusers masked by the ceiling frames as they cross the house. Exhaust is handled through a long, continuous narrow slot at the front of the stage articulated by custom-made wood louvers. The effects are sculptural while serving the pragmatic necessities.

Detail drawing >

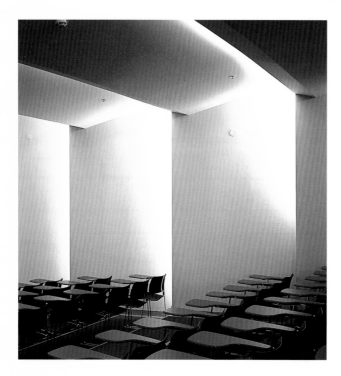

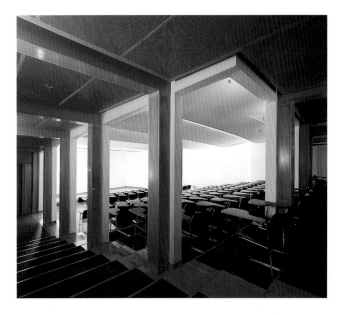

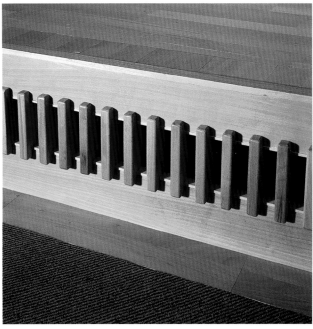

< Detail drawing

A FRAME WITHIN A FRAME WITHIN A FRAME. THE TELESCOPING CONFIGURATION OF THE
BRIGHT WHITE HOUSE SHELLS PULLS THE EYE FORWARD IN PERSPECTIVE. ATTENTION
FALLS ON THE STAGE WHERE THE INSTRUCTOR IS GETTING READY TO SPEAK.

Water pool at base of flume, lower courtyard. >

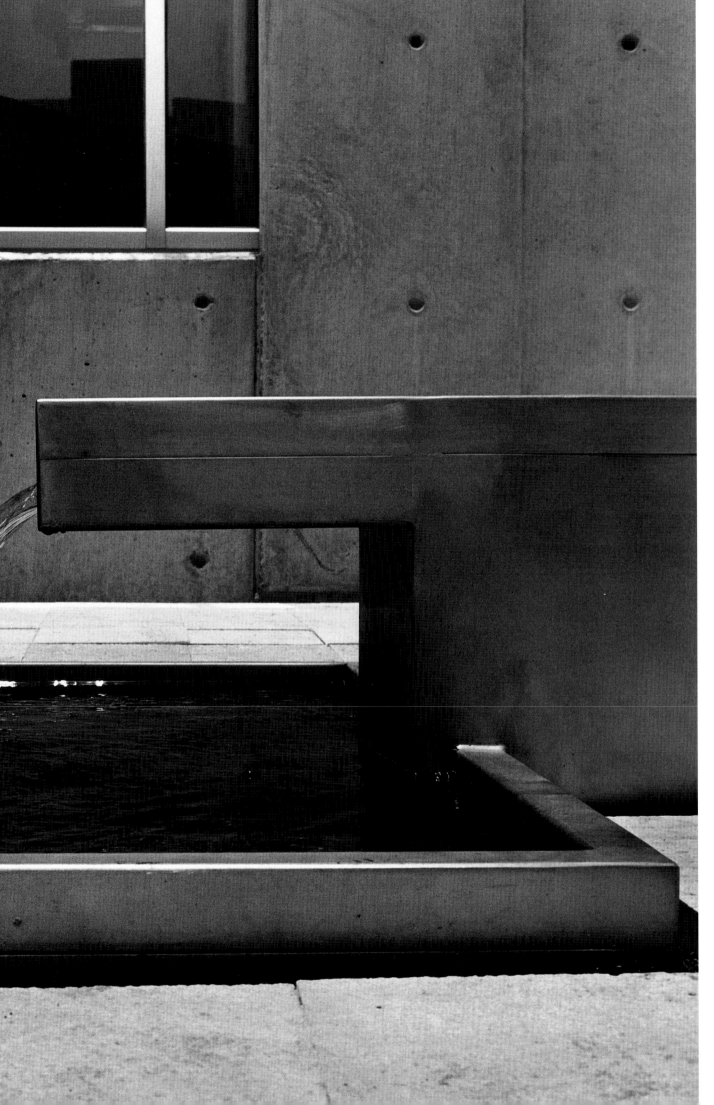

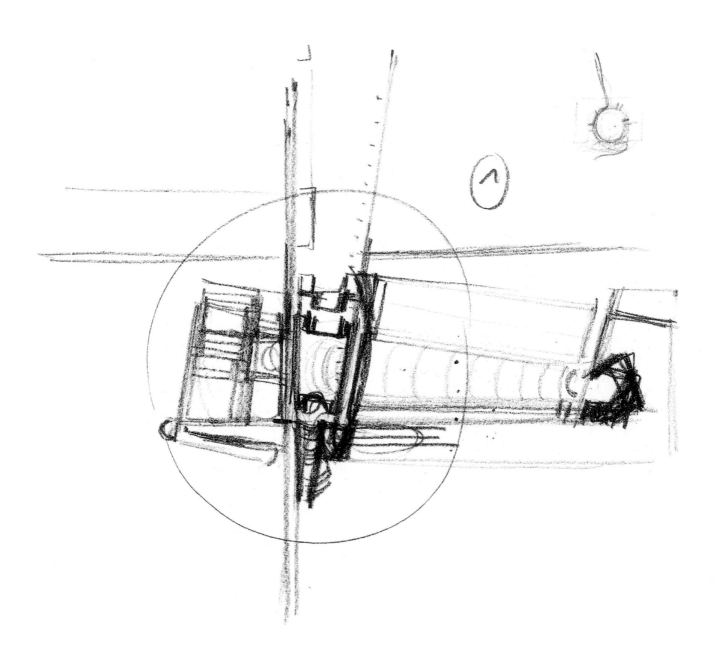

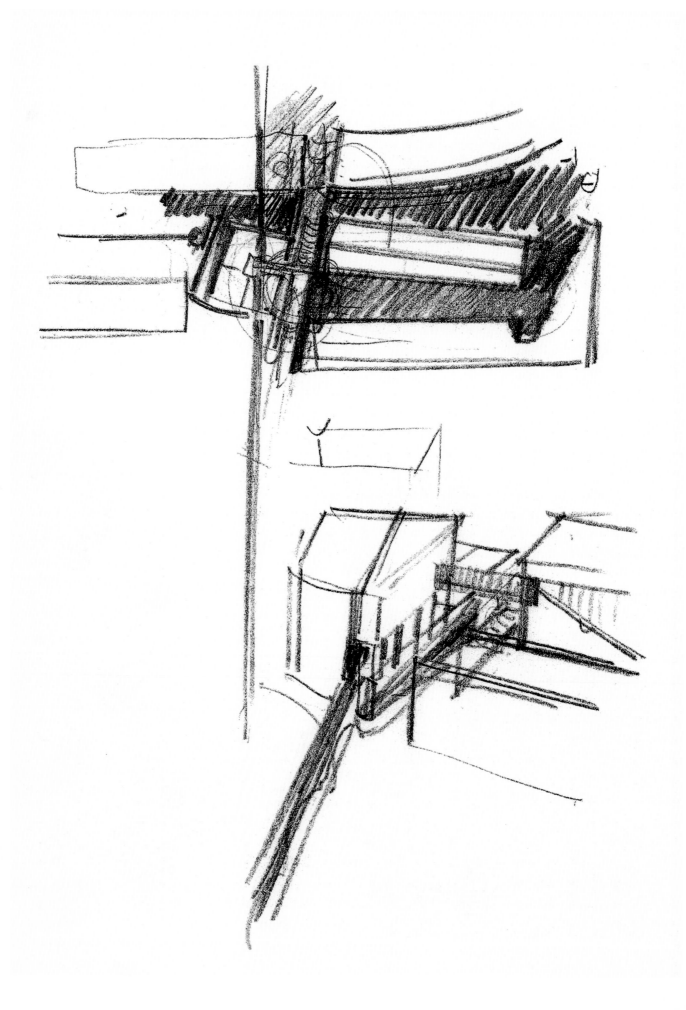

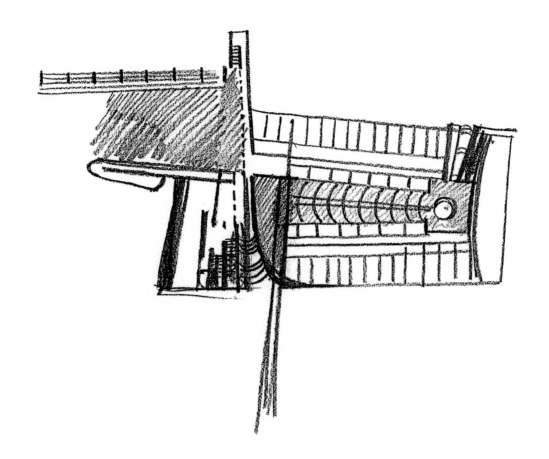

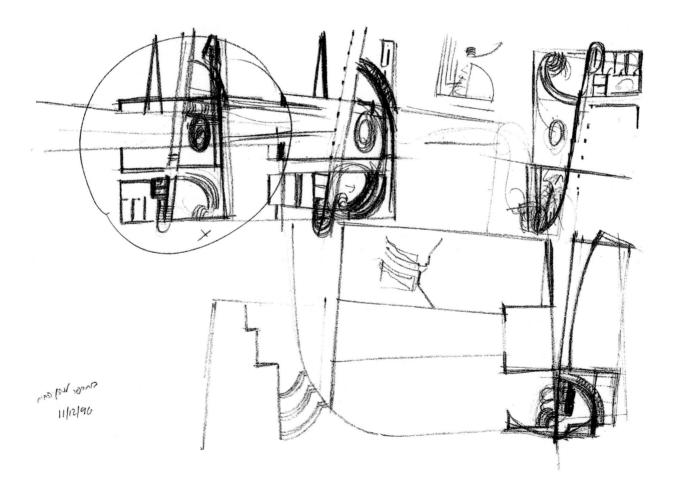

11/12/96

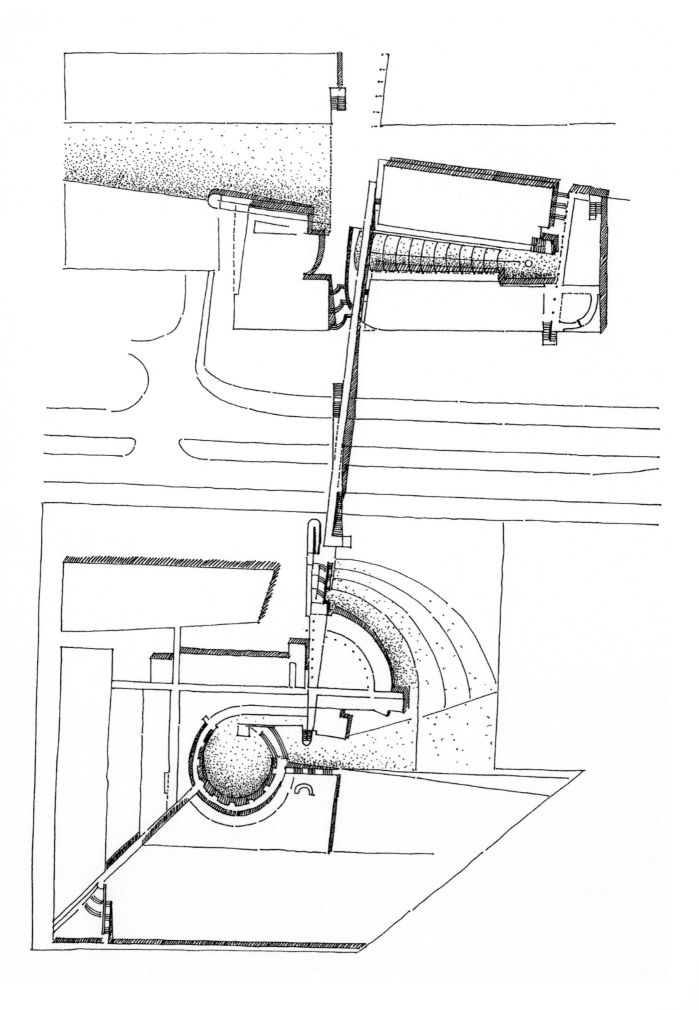

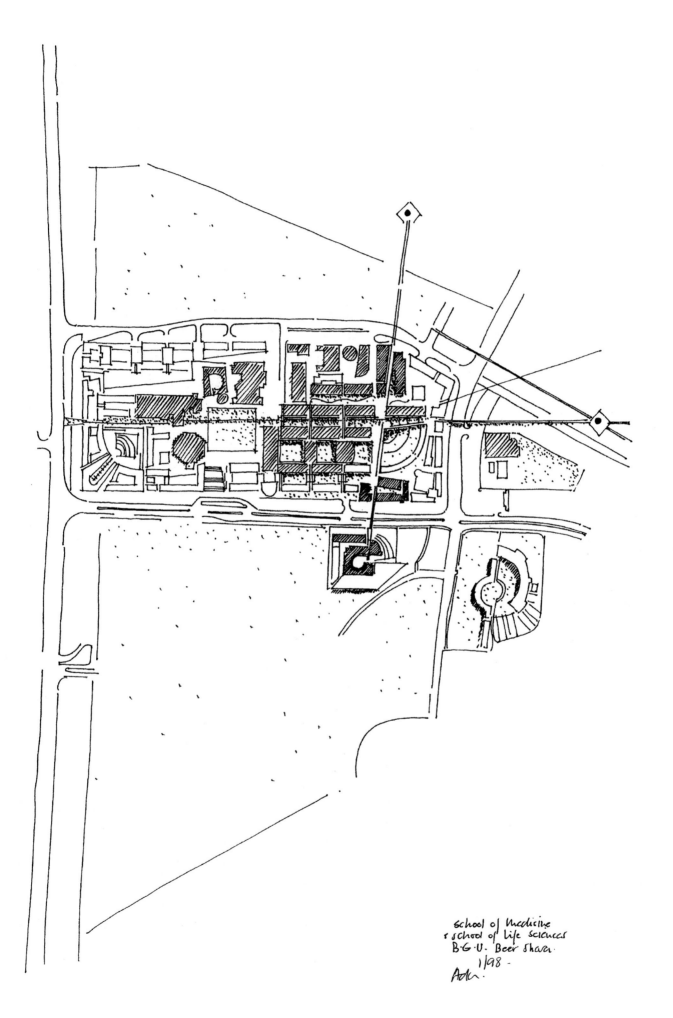

school of Medicine
& school of Life sciences
B·G·U· Beer sheva
1/98 -
Adr.

① David, thanks again for all the drawings – the building starts to make sense now!
I was searching for an elevation (external north and south) that somehow makes sense climatically
in both directions and not be totally different.
The diagram (2) at the bottom has an inclined wall to the south and inclined fins to the north.
The fins would cut the glare and the inclined wall will protect the windows.

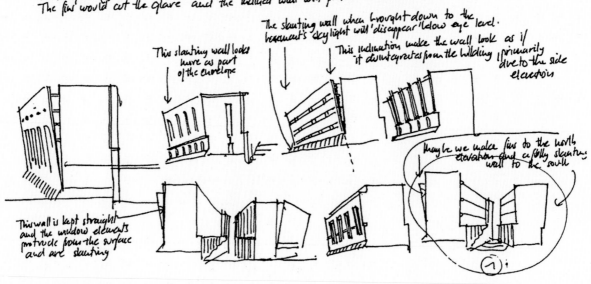

This slanting wall looks more as part of the envelope

The slanting wall when brought down to the basement's daylight will 'disappear' below eye level.

This inclination make the wall look as if it disintegrates from the building primarily due to the side elevations

This wall is kept straight and the window elements protrude from the surface and are slanting

Maybe we make fins to the north elevation and a fully slanting wall to the south

①

②

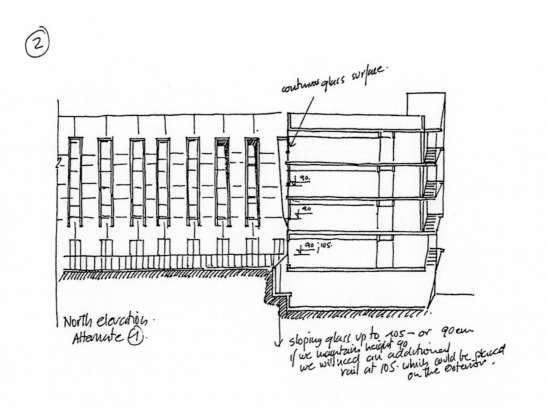

continuous glass surface

90
90
90 105

North elevation.
Alternate ①.

sloping glass up to 105 – or 90 cm
if we maintain height 90
we will need an additional
rail at 105. which could be placed
on the exterior.

③

① The office windows could be set back from the facade, on each side of the room.

② I tried to leave the stair tower in glass first—it later seemed better in concrete.

③ These are joints in the concrete facade.

David I think that this elevation is rich enough without any additions. It could be that hard line rather than soft — will be nice with this drawing too!

It seems to me that if one made a simple section perspective of this building on the side this drawing + the north elevation will be sufficient

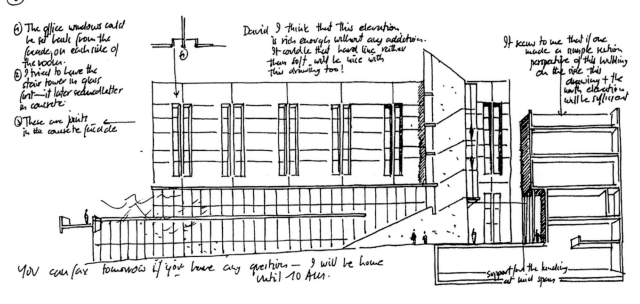

support for the landing at mid span

You can fax tomorrow if you have any questions — I will be home until 10 A.M.

④

It might be possible to find a slope such that the rooms in the base will be somewhat shorter than the rooms in the top; and thereby not exceed the size of the building.

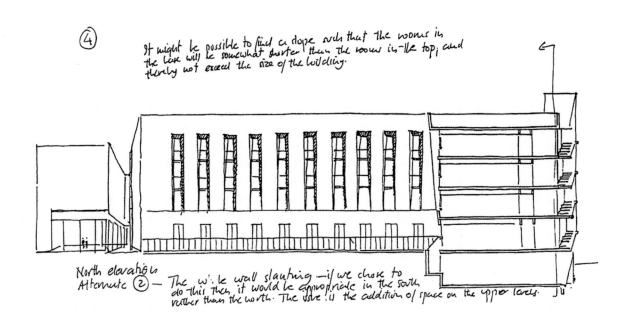

North elevation Alternate ② — The visible wall slanting — if we chose to do this then it would be appropriate in the south rather than the north. The issue is the addition of space on the upper levels.

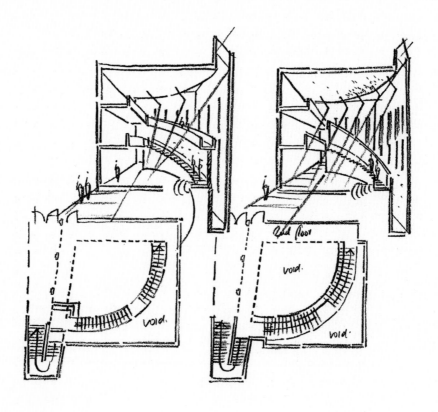

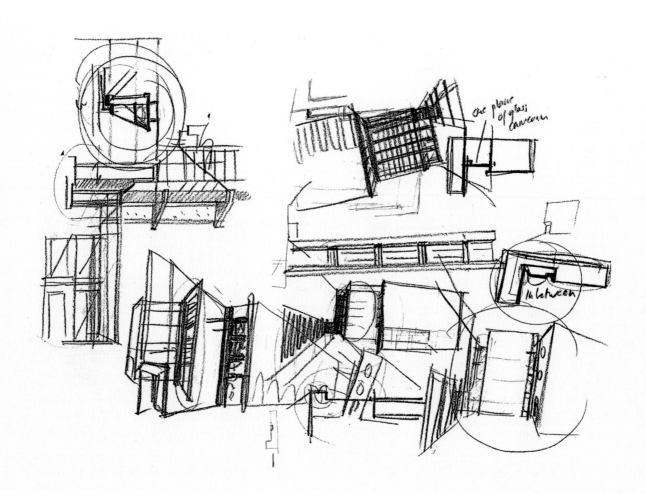

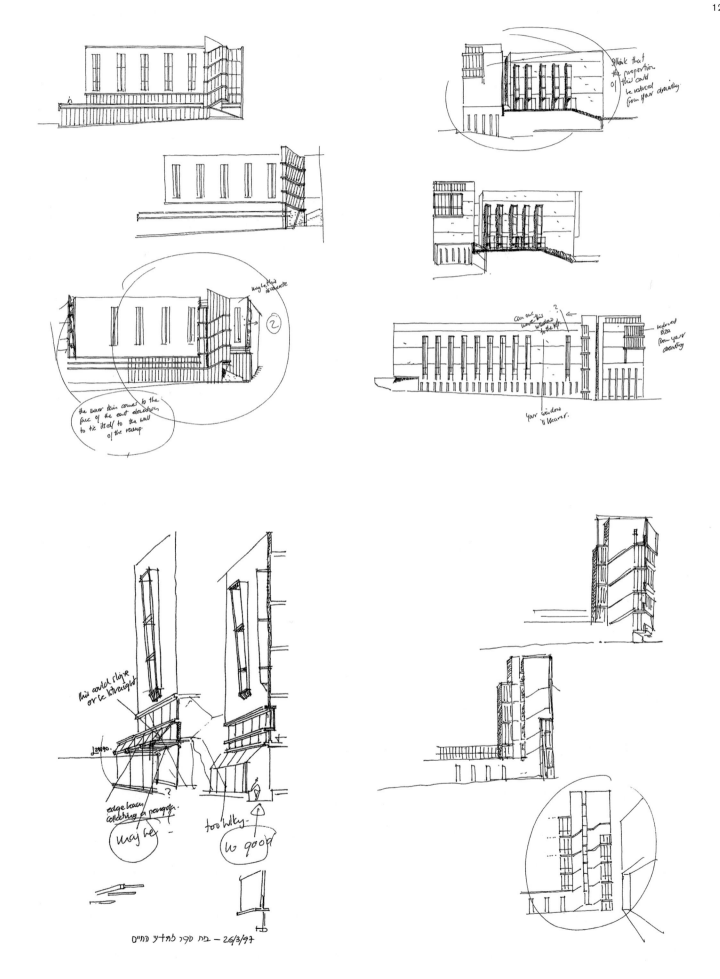

בניה סלע מרכז צעירי חיים – 26/3/97

Toman Family Department of Life Sciences Building [TLSB]

Laboratories, offices, administration facilities, linear exhibition gallery, growing rooms, mechanical and service rooms.

Flexible laboratory modules are located alongside a spine of interchangeable technical support rooms. Disciplines are arranged by floor with student and faculty offices facing the inner garden. Department research is displayed along a publicly accessible gallery at ground floor. Users are professors of the BGU Department of Life Sciences and their graduate students.

Henwood-Oshry Life Sciences Teaching Laboratories Building [HOTL]

Four primary teaching laboratories (for microscopy/biology/microbiology/biochemistry), laboratory support rooms, student lounges, computer lab, 150-seat lecture hall, offices, storage facilities, growing rooms.

Two 40-student labs are located on each of the two main floors with adjacent support facilities and student lounges for relaxation and study. The garden level houses a 150-seat lecture hall, a 25-student computer lab, offices for the supervisors and technicians and storage facilities. Users are BGU undergraduates and their instructors.

de Picciotto Institute of Applied Biosciences Building [IoAB]

Interdisciplinary equipment center, laboratories, offices, greenhouse laboratory, group laboratory wing, 40-seat seminar room, two-story greeting hall, reserved expansion space, mechanical and service rooms, loading dock.

The lowest two floors house a large center for specialized equipment used by scientists from all over campus and from medical center. West wing of institute contains flexible laboratory modules located alongside a spine of interchangeable technical support rooms. Offices of researchers and their graduate students face inner garden. East wing of institute contains special group laboratories, shared facilities for the promotion of group science work. Special two-story glass greenhouse facing southern exposure is used as an adjacent lab. The institute's activities revolve around a central greeting hall off the main inner garden that serves as a living room for the entire complex. Users are PhD researchers from BGU and their research teams.

Life Sciences Complex [LSC]
Total project area: 14,500 sq. m.

WORK IN PROGRESS

The Avi Chai Institute, Jerusalem
An educational faculty including classrooms, auditorium,
library (11,000 sq. m.). Completion scheduled for 2006.

The Open University, Raanana
Master Plan for the entire facility covering a 15-acre site.
First phase includes a new library, classrooms and administrative
offices (37,000 sq. m.). Completion scheduled for 2005.

Deichmann School for the Health Professions, Beer Sheva
School containing classroom, lecture halls and administrative
offices (4,650 sq. m.). Completion scheduled for 2003.

Hadassa Residential Complex, Tel-Aviv
Apartments, offices, health center and parking facilities (55,700 sq. m.).
Completion scheduled for 2003.

The Lauder School of Government, Policy and Diplomacy/
The Arison School of Business/The Interdisciplinary Center, Hertzliya
Academic facility for graduate and undergraduate studies (4,650 sq. m.).
Completion scheduled for 2003.

WORK COMPLETED

Gotenstein Villa, Ramat Hasharon
Private house in Ramat Hasharon (325 sq. m.). Completed, 2000.

BGU Medical School
Ben-Gurion University of the Negev, Beer Sheva
Medical School (7,000 sq. m.). Completed, 1999.

Herzikowitz Villa, Tzahala
Private house in a northern suburb of Tel-Aviv (420 sq. m.)
Completed, 1997.

Ein Harod Museum, Kibbutz Ein Harod
Addition to the existing museum (1,860 sq. m.).
Design Phase One completed, 1994.
Construction of new offices completed, 1996.
New archives and bookshop completed, 1998.

Rabinowitz Villa, Savyon
Private house in a suburb of Tel-Aviv (370 sq. m.). Completed, 1996.

Mirkin Villa, Tel-Aviv
Private house in Tel-Aviv (280 sq. m.). Completed, 1995.

The Israel Supreme Court Building, Jerusalem
First prize (with Ram Karmi) in international competition held in 1986.
Commission for court building includes all the exterior/interior design,
custom furniture and landscaping. Total project size: 23,200 sq. m.
First Phase completed, 1993.
Second Phase completed, 1995.
Third Phase under construction.

Kaufmann Villa, Tzahala
Private house in a northern suburb of Tel-Aviv (370 sq. m.).
Completed, 1991.

DEVELOPMENT

Client: Ben-Gurion University of the Negev
President: Dr. Avishay Braverman
Director-General: Dr. Israel German
Deputy Director-General for Development: Pinhas Kedar

DESIGN & ENGINEERING

Architecture: Ada Karmi-Melamede & Partners, Architects
Designer: Ada Karmi-Melamede
Project Architect: David S Robins
Project Team: Ofer Arussi, Yasmin Avissar, Sharon Paz-Gersh,
Ifat Finkelman, Dina Shafrir, Haki Zamir

Structural Engineering: Rotbart-Nissim Structural Design, Ltd.
Principals: Eli Rotbart, Isaac Nissim
Project Engineer: Avitzur Benbenishti

HVAC Engineering: H.R.V.A.C. Consulting Engineering Co., Ltd.
Principals: Uri Har-el, Uri Stroum
Project Engineer: Uriya Raanan

Electrical Engineering: J. Brand, Ltd.
Principal: Jakob Brand

Civil and Sanitary Engineering:
Environmental Engineering & Technology, Ltd.
Principal: Ami Herson

Lighting Engineering: Israelight Ltd., Architectural Lighting Design
Principals: Angela & Gad Giladi

Façade Engineer: Landmann Aluminium, Ltd.
Principal: Joseph Landmann

Landscape Planning: Yaron-Ari Landscape Design, Ltd.
Principal: Mordechai Yaron

Laboratory Planning: Sherman-Potash Architects, Ltd.
Principal: Zadok Sherman
Project Architect: Ruti Aloosh

Security & Communications Engineering:
Electronic Management Group, Ltd.
Principal: Eli Peltz
Project Engineer: Moshe Shacham

Safety Engineering: S. Natanel Engineers & Consultants, Ltd.
Principal: Shmuel Natanel
Project Engineer: Efraim Ben-Ami

MANAGEMENT

Project/Construction Management: Hirshberg-Milun Engineers, Ltd.
Project Manager: Uri Doron
Site Engineer: Dani Dinari
Supervisors: Yigal Rabinovitch, Zion Kedar

CONSTRUCTION

General Contractor: Ashlil Constructing & Investment, Ltd.
General Manager: Amnon Szekely
Project Engineer: Ezra Assaf
Site Manager: Shimon Moradian

Mechanical Systems: Mashav, Ltd.
Project Manager: Alon Strugano

Electrical Systems: Noga, Ltd.
Project Managers: Moshe Don, Avi Maimon

Civil and Sanitary Systems: Herout, Ltd.
Project Manager: Tuvia Ziv-Av

Communications Systems: Bynet, Ltd.
Project Manager: Benny Yashuv

Window and Curtain Wall Systems: Extal, Ltd.
General Manager: Eli Harush

Façade Contractor: Razpal Aluminum, Ltd.
General Manager: Avraham Boneh
Project Manager: Zvi Mahlou

Glass Prisms: Vang Brothers, Ltd.
General Manager: Dov Vang

Stainless Steel Fabrication: Yosan, Ltd.
General Manager: Isaak Nachshon

Ironmongery: Mir Metals, Ltd.
General Manager: Rami Chemo

Landscaping: Seviva Yeruka, Ltd.
General Manager: Hana Paysano

Exterior Paving & Site Development: Solel-Boneh, Ltd.
Project Manager: Igor Sterer

Carpentry: Segal Carpentry
General Manager: Gideon Segal

Office Furniture: Gilboa, Ltd.
Project Manager: Nisim Eini

Laboratory Furniture: Fine-Lab, Ltd.
Project Manager: Meni Rozenvaig

Fumehoods: Mintz, Ltd.
General Manager: Amnon Mintz

Wall Coverings & Ceilings: Beta Acoustic Technology, Ltd.
General Manager: Joseph Bas

Wall Coverings: Israel Scandetex, Ltd.
General Manager: Ziva Talmor

Stone Flooring: Alony Marble, Ltd.
General Manager: Yossi Zimbris

PVC Flooring: Gum Technica, Ltd.
General Manager: Micha Stern

Signage: Molcholand, Ltd.
General Manager: Ilan Molcho

Fiber Optic Lighting: M. C. S. Israel
General Manager: Dr. Rueven Azoury

PHOTOGRAPHY

Hélène Binet
16–17, 19, 20–21, 22, 24–25, 26, 27, 30, 31, 32–33, 34, 35,
36–38, 39, 40–41, 42, 43, 44–45, 46, 47, 48–49, 50, 51,
52–53, 54, 55, 56–57, 58, 59, 60–61, 62, 63, 64–65, 66, 68–69,
70, 71, 72–73, 74 left, 75 bottom, 76–77, 79, 80–81, 82 left,
84–85, 87, 88–89, 90, 91 top, 92–93, 94 right, 95, 96–97, 98, 99,
100–101, 102, 103, 104–105, 106 left, 108–109, 110 left,
112–113, 116–117

Amit Geron
18, 23, 67, 75 top, 78, 82 right, 106 right, 107 top, 110 right, 111,
114, 115

David S Robins
28–29, 74 right, 83, 86, 91 bottom, 94 left, 107 bottom

Sharon Yaari
55

SKETCHES

Ada Karmi-Melamede
pen & ink: 122, 123, 124, 125, 127
pencil: 119, 120, 121, 126